CARIBBEAN COAST

COSTA RICA **REGIONAL GUIDES**

Yazmín Ross and Luciano Capelli

AN OJALÁ EDICIONES & ZONA TROPICAL PUBLICATION
from
COMSTOCK PUBLISHING ASSOCIATES
an imprint of
CORNELL UNIVERSITY PRESS
ITHACA AND LONDON

First published 2019 by Cornell University Press

Printed in China

Library of Congress Cataloging-in-Publication Data

Names: Ross, Yazmín, 1959– author. | Capelli, Luciano, author.
Title: Caribbean coast / Yazmín Ross and Luciano Capelli.
Description: Ithaca : Comstock Publishing Associates, an imprint of Cornell University Press, 2019. | Series: Costa Rica regional guides |
"An Ojalá Ediciones & Zona Tropical publication." | Includes index.
Identifiers: LCCN 2019008049 | ISBN 9781501739293 (pbk. ; alk. paper)
Subjects: LCSH: Atlantic Coast (Costa Rica)—Description and travel. |
Natural history—Costa Rica—Atlantic Coast.
Classification: LCC F1549.A85 R67 2019 | DDC 917.28604—dc23
LC record available at https://lccn.loc.gov/2019008049

Front cover photo: Luciano Capelli
Back cover photo: Gregory Basco

COSTA RICA REGIONAL GUIDES

The world knows Costa Rica as a peaceful and environmentally conscious country that continues to attract several million tourists a year, yet this image may obscure a social and biological legacy that very few visitors get to know.

We hope that the six books in this collection will reveal a reality beyond the apparent one. These are meant to pique the curiosity of travelers through stories about nature, geology, history, and culture, all of which help explain Costa Rica as it exists today.

Each title is dedicated to those who fought, and continue to fight, with grace and wisdom, for a natural world that lies protected, in a state of balance, and accessible to all, in other words, one that is closer to the ideal we seek to make real.

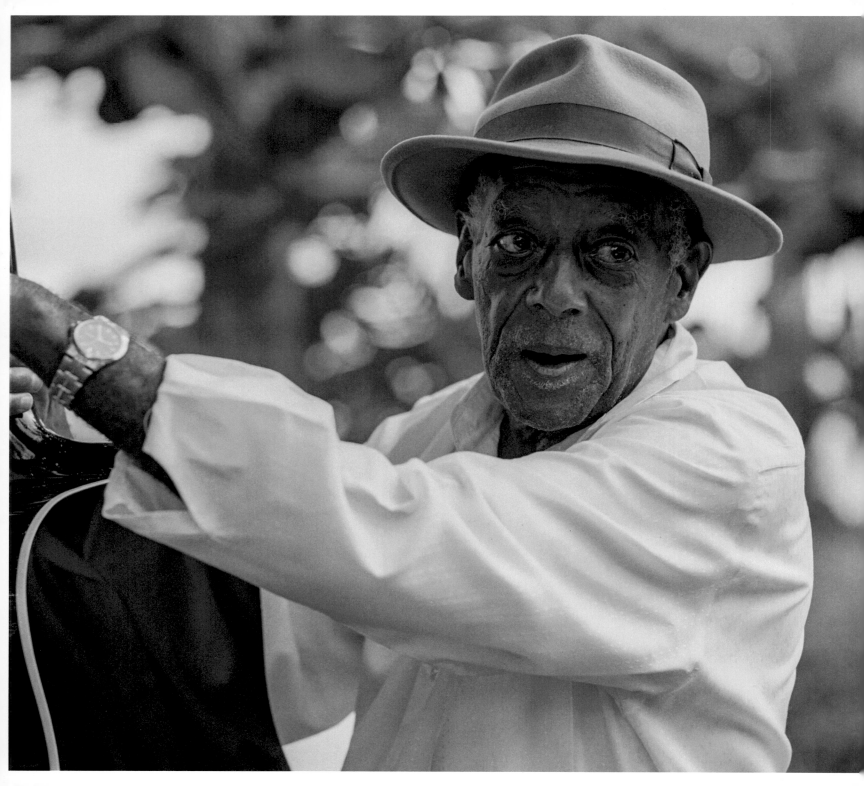

DEDICATION
WALTER GAVITT FERGUSON

For many years, Limón and the southern Caribbean were written off as travel destinations, having been labeled, unfairly, the most dangerous places in the country. The rich culture of this region was denigrated by some, said to be nonexistent by others. The music of Walter Ferguson would begin to change all of this. His calypso songs, stories really, about life in this region, are laced with poetry, love, humor, self-irony, and respect.

This lively personality, as kind as only an old gentleman can be, with a flavorful Jamaican accent and constant openness to conversation, first became known abroad, thanks to an album he recorded in 1982 for the most prestigious ethno-graphic music collection in the world, the Folkways World Music Collection. In this country, his calypso songs would later become popularized through versions performed by Cantoamérica, a famous Costa Rican band. Finally, in 2002, his songs would be sung in his own voice and recorded in an improvised studio in Cahuita.

Today Don Walter is almost 100 years old, and although he no longer composes, he is still a symbol of Caribbean culture. He is the village bard, a historian of sorts, who conjures up a Cahuita that was a simple village of fishermen and cacao growers, before the creation of the national park and the arrival of tourism.

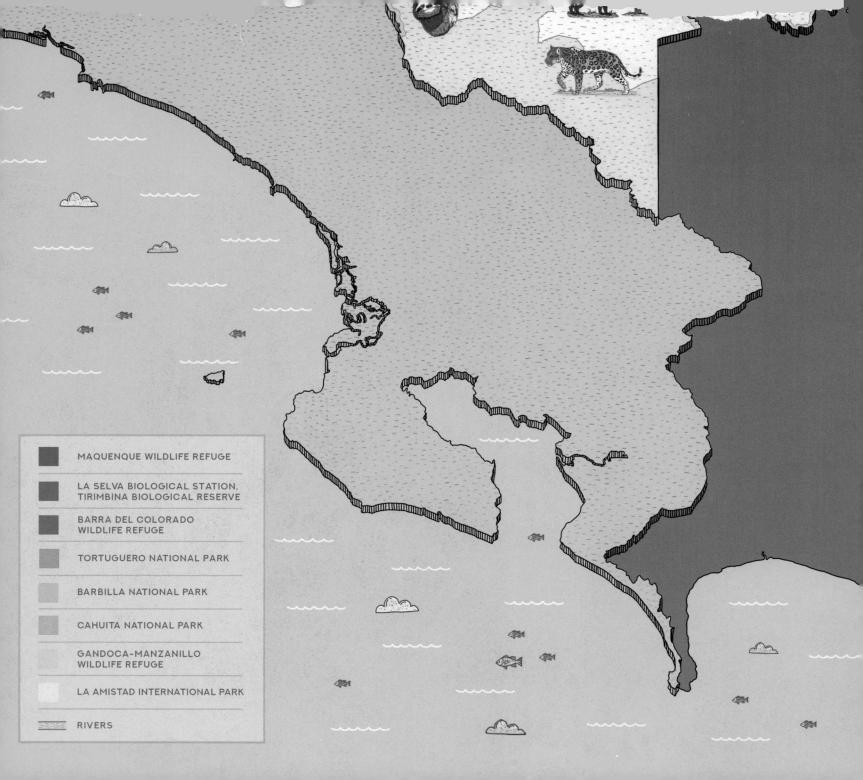

MAQUENQUE WILDLIFE REFUGE

LA SELVA BIOLOGICAL STATION,
TIRIMBINA BIOLOGICAL RESERVE

BARRA DEL COLORADO
WILDLIFE REFUGE

TORTUGUERO NATIONAL PARK

BARBILLA NATIONAL PARK

CAHUITA NATIONAL PARK

GANDOCA-MANZANILLO
WILDLIFE REFUGE

LA AMISTAD INTERNATIONAL PARK

RIVERS

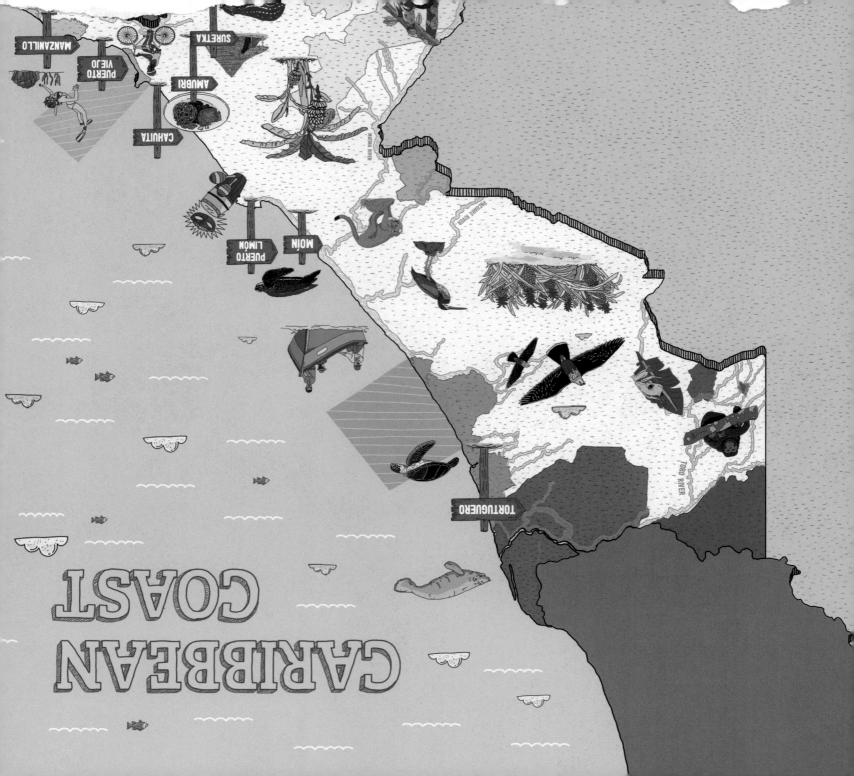

CARIBBEAN COAST

COSTA RICA 〰〰 REGIONAL GUIDES

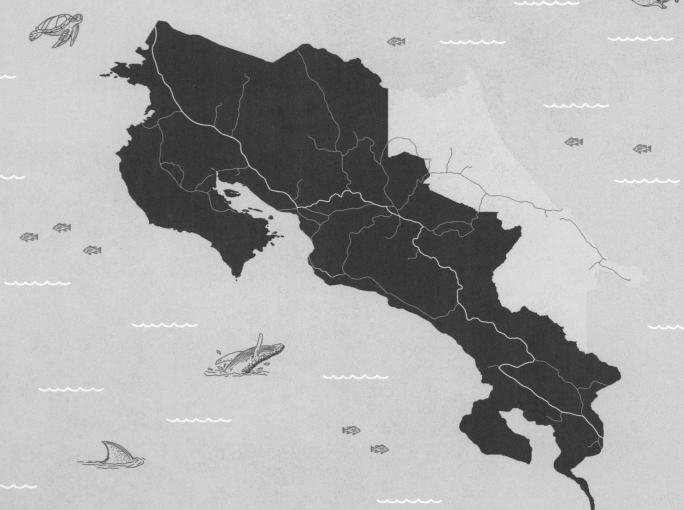

CONTENTS

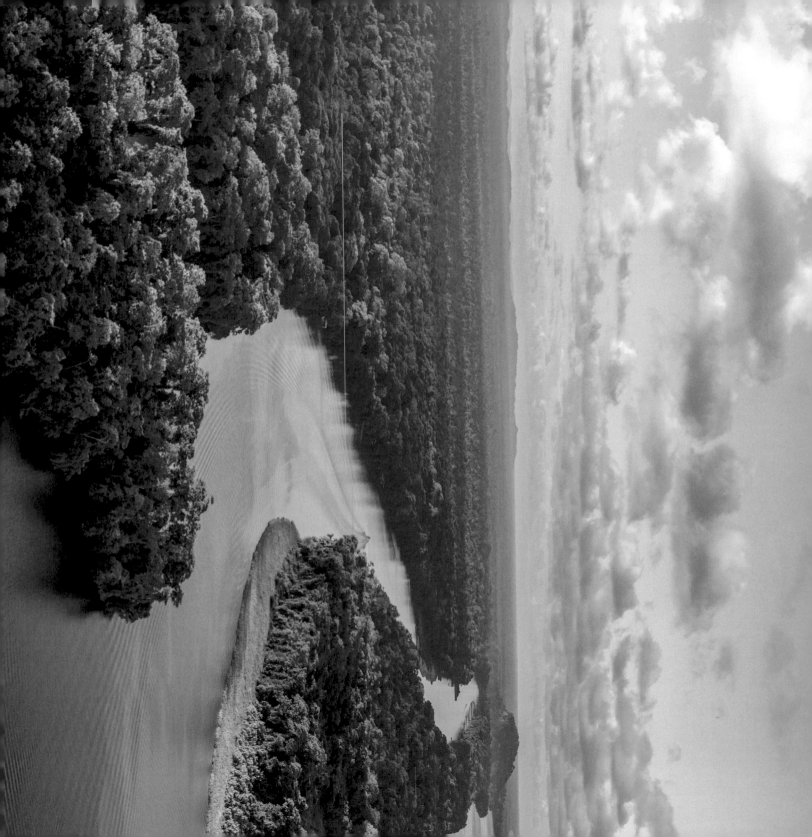

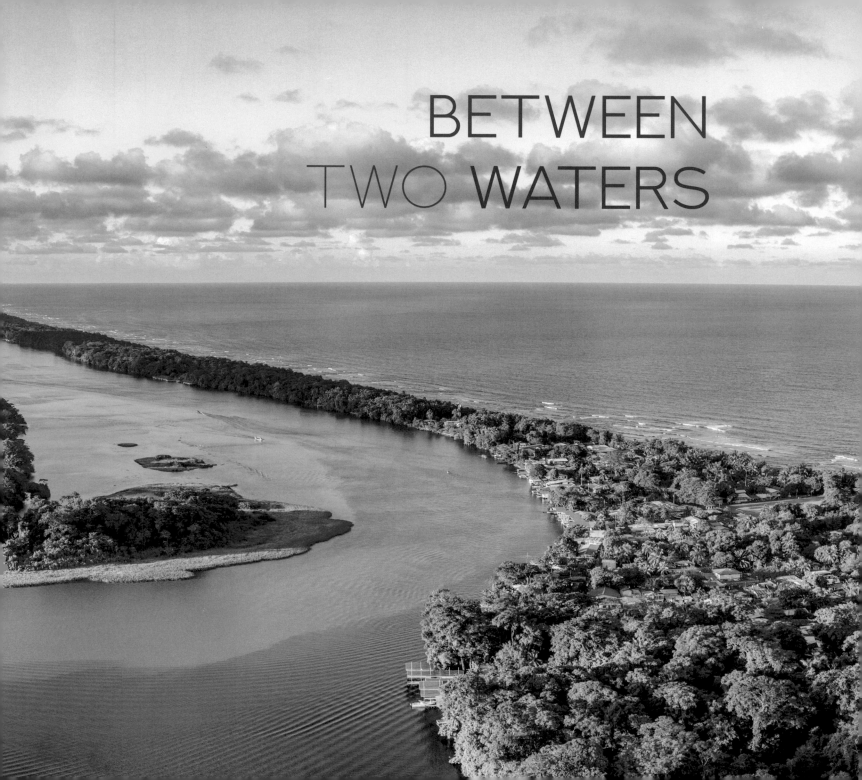

BETWEEN
TWO WATERS

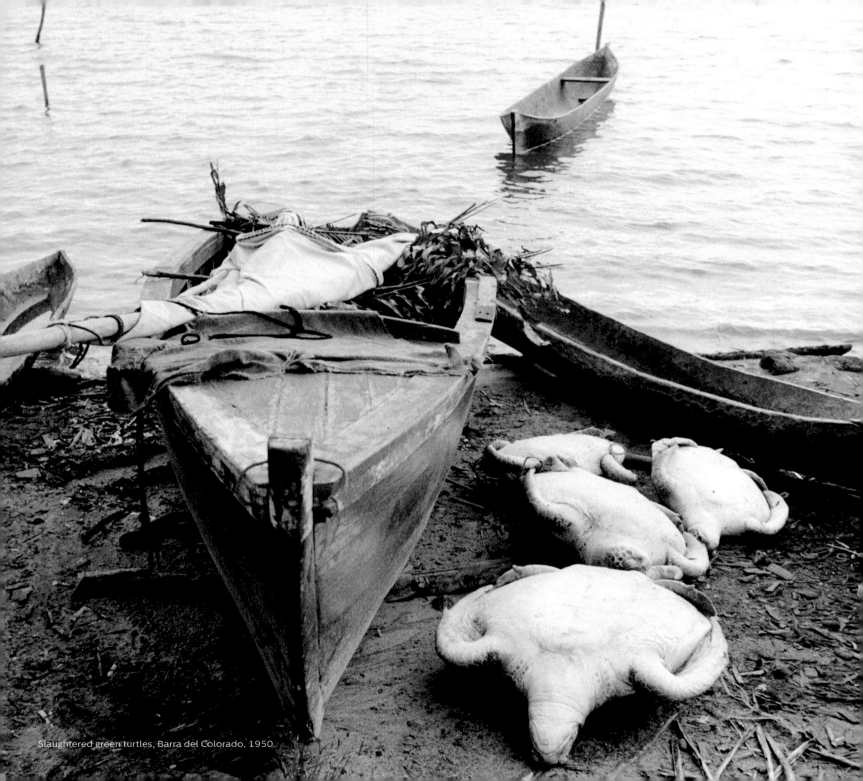
Slaughtered green turtles, Barra del Colorado, 1950.

It was called Suerre. In the language of the Huetars, *sue* means river and *ri* means turtle. The earliest inhabitants were Talamanca indigenous peoples who dedicated themselves to hunting green turtles along the coast of the country, as well as manatees on a system of rivers and lagoons that are known today as the canals of Tortuguero.

Thanks to its abundant wildlife, Suerre once served as a supply station for travelers along the Caribbean coast. These included Mayan traders of the Pre-Hispanic period and, in the 19th century, fishermen in fleets coming from the Colombian islands of San Andrés and Providencia. These fishermen would often encounter Miskito indigenous peoples who arrived each year from the north to hunt carey turtles.

Until 1974, when the canals were finally opened, Tortuguero was completely isolated from most of the country. Its only connection was with other coastal towns and there were large inland rivers that allowed access to Barra del Colorado and the San Juan River, whose communities all sustained themselves through the cutting of hardwoods, the hunting of turtles, and the production of coconut oil.

To connect this area of the northern Caribbean to the rest of the country required dredging 12.5 miles (20 km) of new canals, a project that began in 1967. "The rest was simply a matter of connecting existing lagoons and rivers," explains Rogelio Pardo, a civil engineer who was an early promoter of the project and who played a key role in the construction of a section of the canal.

To open the canals for navigation "...they dynamited the trees with strings of explosives," relates Sabina Cabrera, owner of a small rustic lodge and one of the founders of the village. "This was all jungle. There was nothing else here. The fer-de-lance snakes were all over." In the 1950s, a Mississippi lumber company opened a lumber mill and a shipping dock. The rafts of cut hardwood trees were towed by barges left over from the World War II.

The once extensive forests of Tortuguero today are doors that open and close offices in the US, or serve more ephemeral purposes, as boxes for Cuban cigars, packing crates, and chopsticks. The only thing left in the non-protected areas are muddy pastures in which cows sink up to their knees.

Open to the fury of wind and storms, the sea here is often turbulent. The beaches have a wild cast to them, plagued by rip currents and strewn with flotsam and other debris, seaweed, and fallen tree trunks, where sea birds seek cover from the blowing foam. On this spot each year, green turtles (*Chelonia mydas*) lay their eggs *en masse* between July and October.

Green turtles have a hard shell, dark leathery skin, and heads with scales that bear yellow borders. They live longer, biologists believe, than any other species of marine turtle, some perhaps to 130 years, and are the slowest to reach sexual maturity, starting reproduction between 30 and 50 years of age.

In the early 1960s, the green turtles were close to disappearing, their population having been reduced by 95% due to four centuries of hunting the adults and their eggs. In 1975, a pair of scientists from the University of Florida, Archie and Marjorie Carr, having established their credentials through research

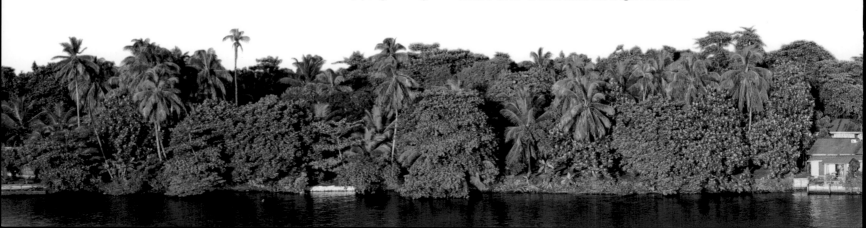

and publications, convinced the government of Costa Rica to convert Tortuguero, the most important nesting site in the Caribbean, into a national park.

At the time, local inhabitants were bewildered by the efforts of the conservation biologists. Pedro Barrios, a Nicaraguan from Ometepe Island who settled in Tortuguero more than 40 years ago, recalls "...the turtle scientist Karl [Archie Carr] came. He put tags on the turtles, and then would leave when the egg-laying season was over. The next year he would come back with more biologists from the University of Florida. Each person would oversee a mile and a quarter of beach. And there was the gringo [Carr] with his compass looking at the path the turtles took."

The Carr's efforts paid off, and the Caribbean Conservation Corporation was born in 1959. Under its stewardship, the number of turtles that arrive each year has grown from 3,000 in the 1960s to 30,000 today. Unfortunately, the Carrs did not live to see the results of their work; the turtles they protected in the 1960s would return to lay eggs in Tortuguero at the beginning of the new millennium. Today these turtles are a source of livelihood for the community, providing not food but a constant source of wonder for the tourists who come to see them.

The green turtle is not the only inhabitant of Tortuguero National Park, however. This protected wilderness is also a refuge for other species of turtle, the hawksbill, the leatherback, and the olive ridley; for felines such as the jaguar and the ocelot; and for the three-toed sloth, the manatee, the tapir, and the white-faced capuchin, howler, and spider monkeys. Tortuguero is also a paradise for birdwatchers.

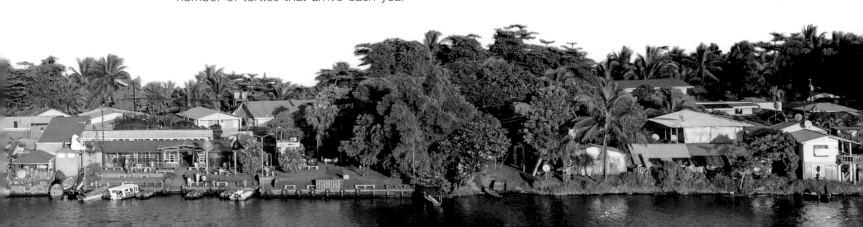

The best way to explore the canals of this flooded jungle is to do what the first inhabitants did and hop in a canoe propelled by human power.

Caimans hidden among the vegetation, green iguanas soaking up the sun, and scampering river otters all await the patient observer with an attentive gaze.

Moving south, after traversing 30 miles (50 km) of black, deserted beaches interrupted only by the occasional river mouth, you reach the Pacuare Biological Reserve, the most important nesting site for the leatherback turtle in the Caribbean and the best place to observe it.

The leatherbacks are the last surviving species of the family Dermochelyidae. Watching them nest is like traveling back to the era of the giant reptiles, when turtles reached 13 feet (4 m) in length and weighed 4800 pounds (2200 kg). The leatherback is the fourth largest reptile on the planet, preceded only by three species of crocodile.

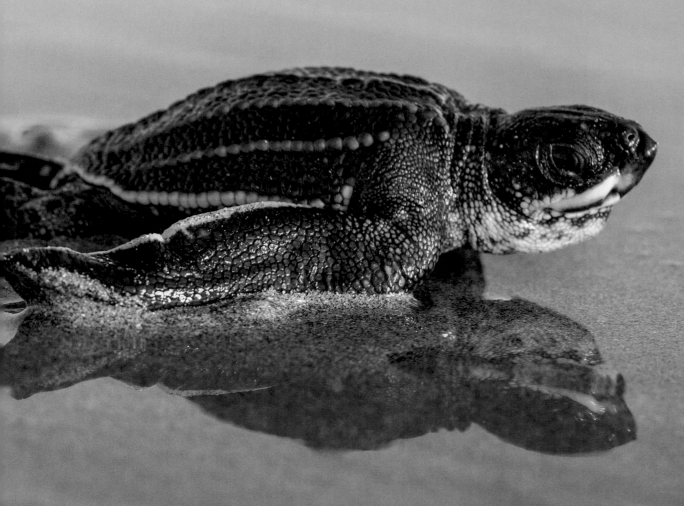

Leatherback turtle (*Dermochelys coriacea*)

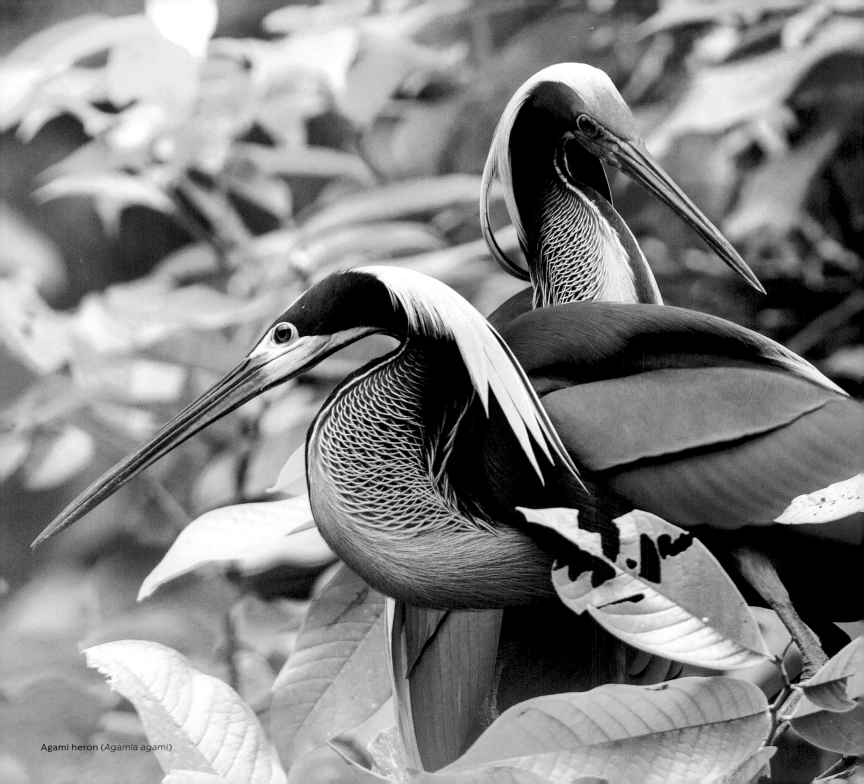

Agami heron (*Agamia agami*)

The leatherback is unique in other respects. It can maintain its body temperature up to 64 °F (18 °C) warmer than the surrounding water. This ability (similar to that possessed by mammals) allows it to make transoceanic journeys and move through cold waters inhabited by its favorite food, jellyfish.

The Pacuare Biological Reserve is the only place in Costa Rica where one can observe the courtship and nesting of the agami heron, a beautifully feathered bird so shy that it is very difficult to see outside of its reproductive season. During courtship, hundreds of them gather in confined places, usually on tiny islands surrounded by lagoons with very thick vegetation.

Moving yet farther south, the coast is un-populated for another 15 miles (25 km). Inland, the expansive wetlands, with their dense jungles and labyrinthine canals, make a local guide indispensable on your journey. One moment the sky promises imminent rain, then the sun appears, then again clouds, reminding you that nothing is predictable on the Caribbean coast.

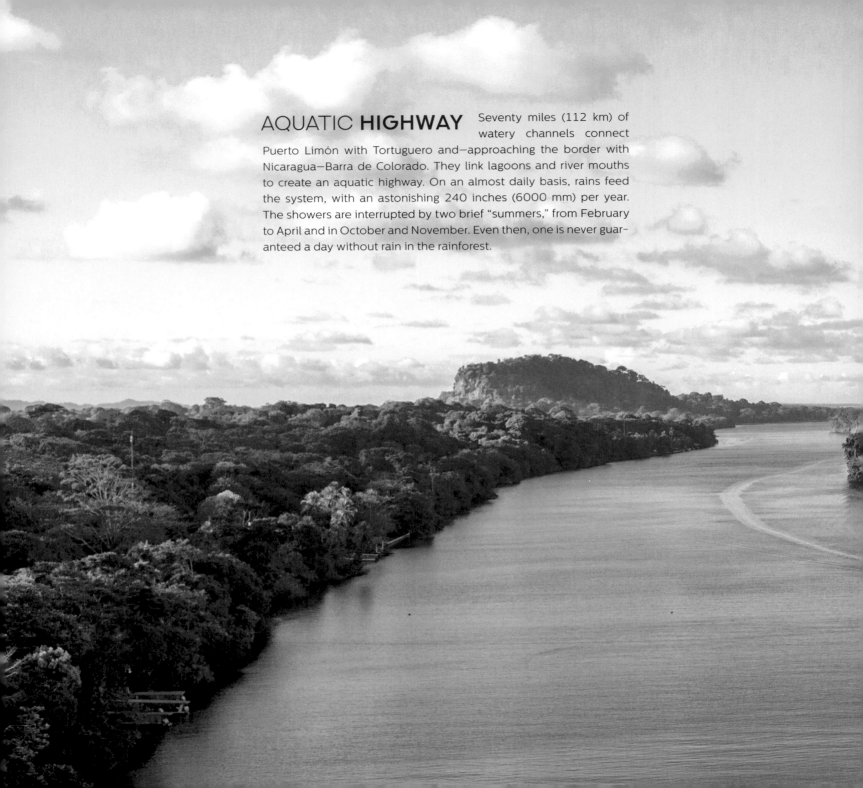

AQUATIC **HIGHWAY**

Seventy miles (112 km) of watery channels connect Puerto Limón with Tortuguero and—approaching the border with Nicaragua—Barra de Colorado. They link lagoons and river mouths to create an aquatic highway. On an almost daily basis, rains feed the system, with an astonishing 240 inches (6000 mm) per year. The showers are interrupted by two brief "summers," from February to April and in October and November. Even then, one is never guaranteed a day without rain in the rainforest.

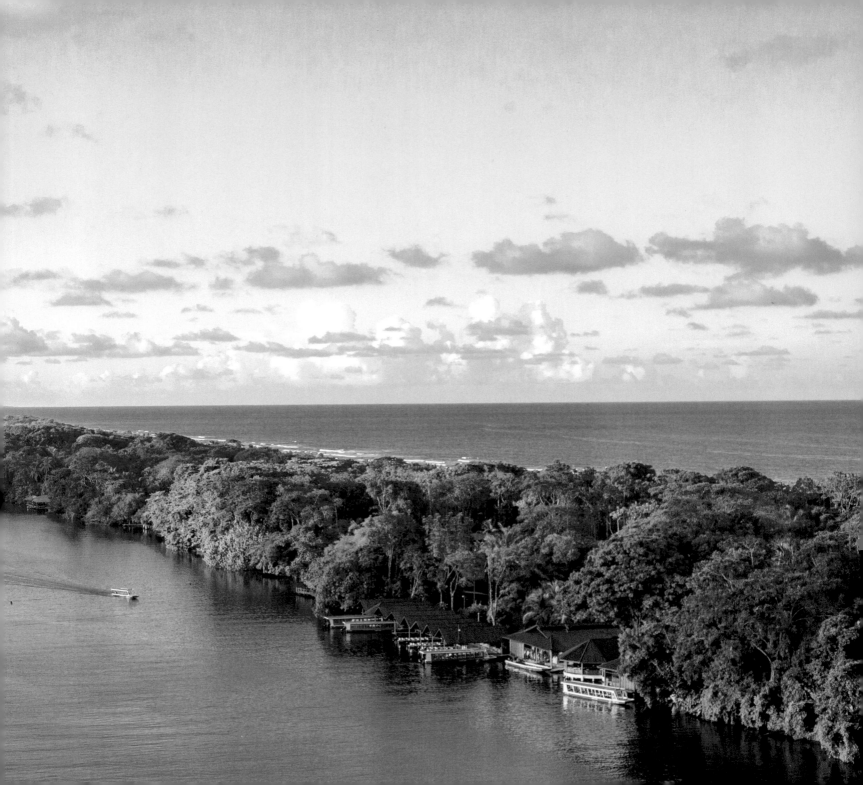

TURTLES AND
JAGUARS

The spawning season of the green turtle, from July to October, attracts dozens of jaguars (*Panthera onca*) from the Caribbean plains. They swim east across the Tortuguero canals at the beginning of the season and stay until prey becomes scarce. When the turtles have departed, they move inland to feed on peccaries, caimans, and small mammals.

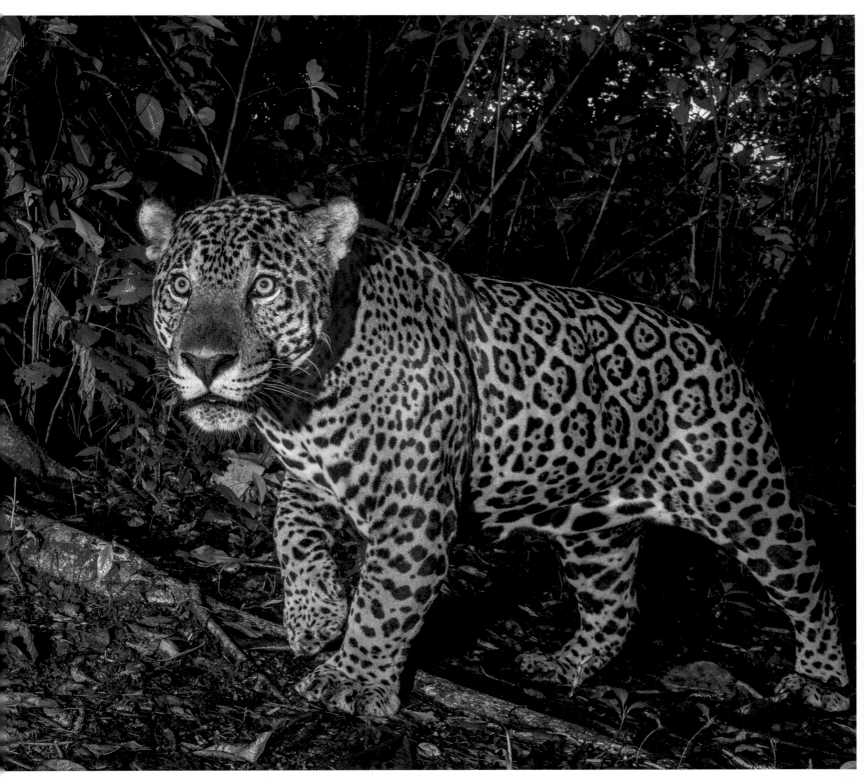

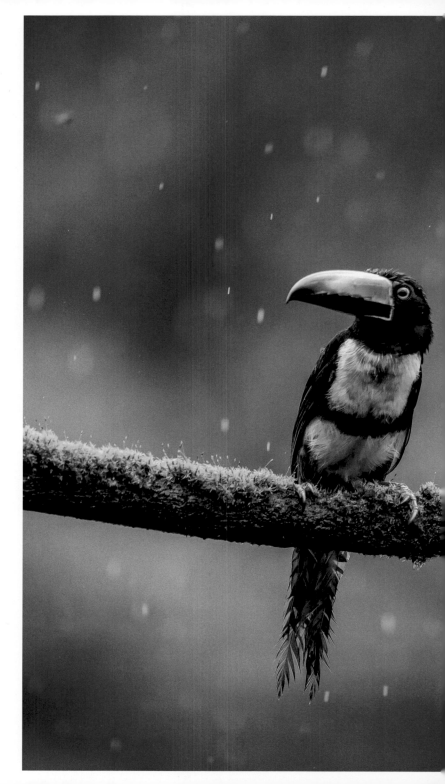

TOUCAN
CLAN

Collared aracari (*Pteroglossus torquatus*) are exceedingly social birds. They feed in flocks of up to 15 individuals, and as many as six toucans may roost within the confines of the same tree hole. It is common to see them at play, nibbling their neighbors with their long beaks or leaping over each other. Care of the offspring is also a collective affair. Up to five individuals have been observed caring for and feeding nestlings; the caretakers include both parents and juveniles from the previous clutch.

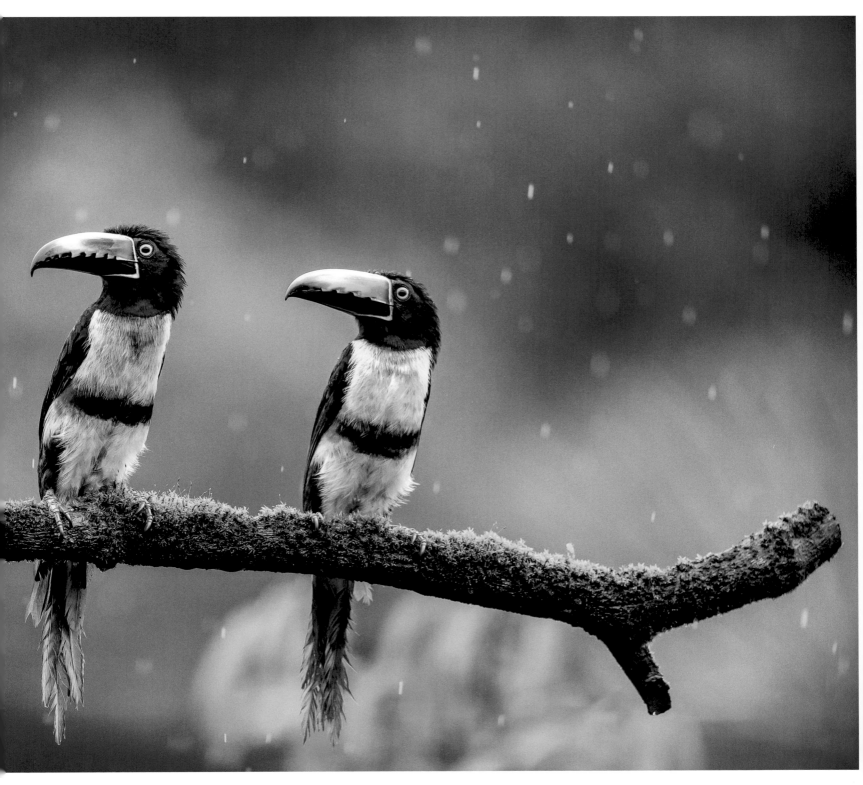

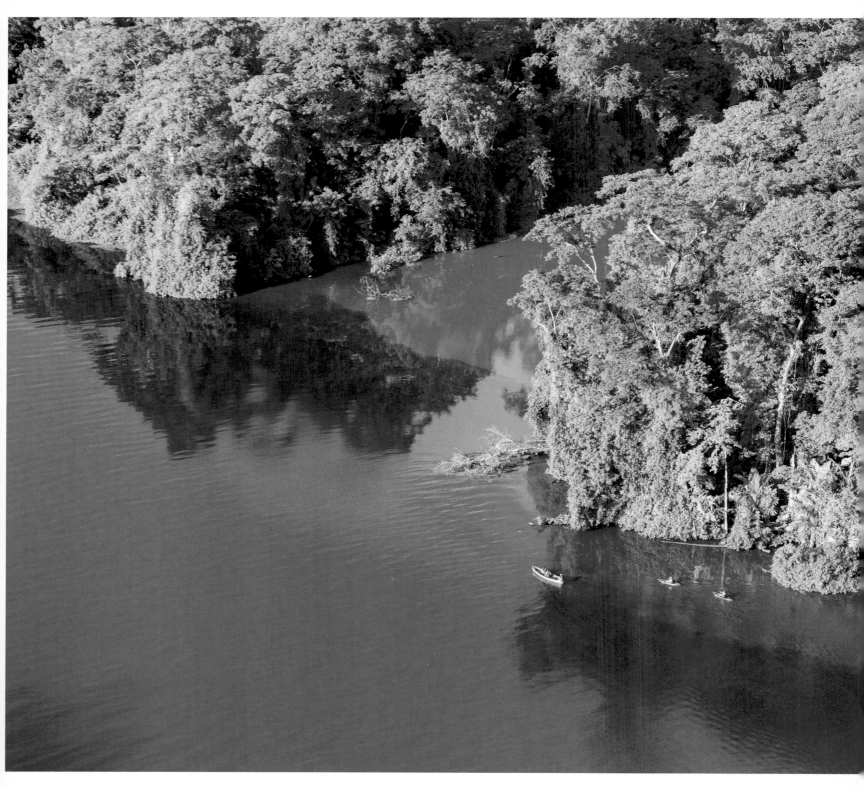

The best way to explore the canals, undoubtedly, is by kayak or canoe, two modes of transport that do not emit noise or diesel fumes. Although many animals have become habituated to boat traffic, the sounds and songs of the forest are best experienced from a silent, floating vessel.

COLORS THAT
SPEAK

There are colors made to attract and others to ward off the uninvited, exemplified by these two very different animals. The male keel-billed toucan (*Rhamphastos sulfuratus*) relies on his splendid plumage to court females, as he shakes his head and lifts his tail. But the strawberry poison dart frog (*Oophaga pum-ilio*) uses its bright colors to warn potential predators of its poisonous skin toxins.

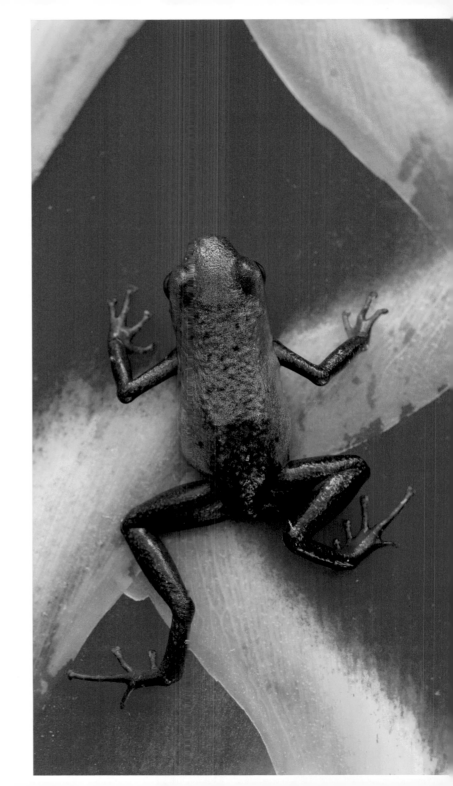

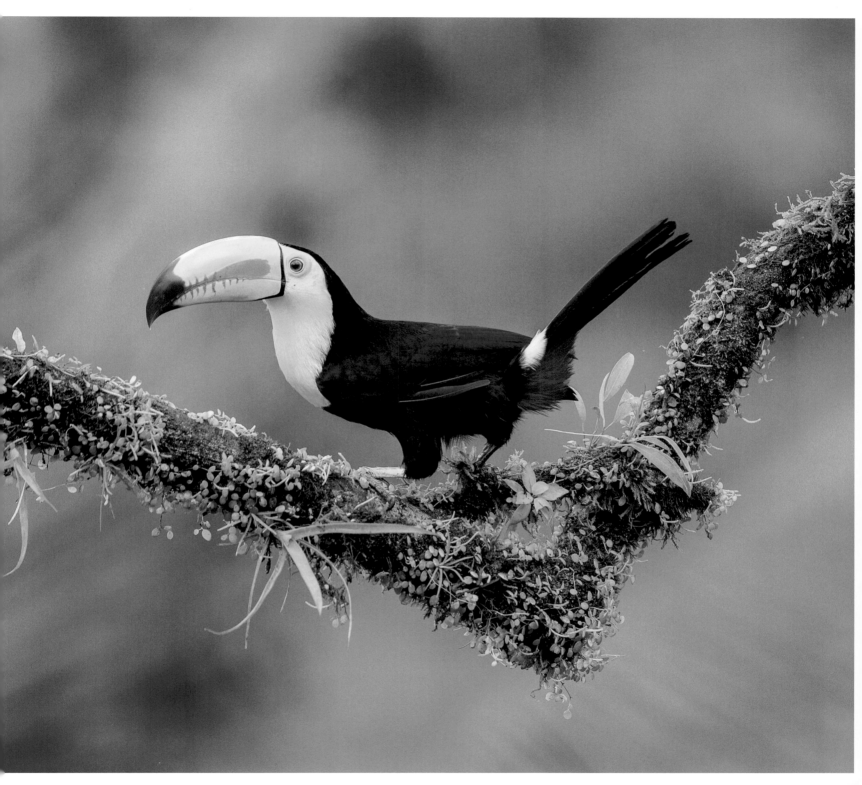

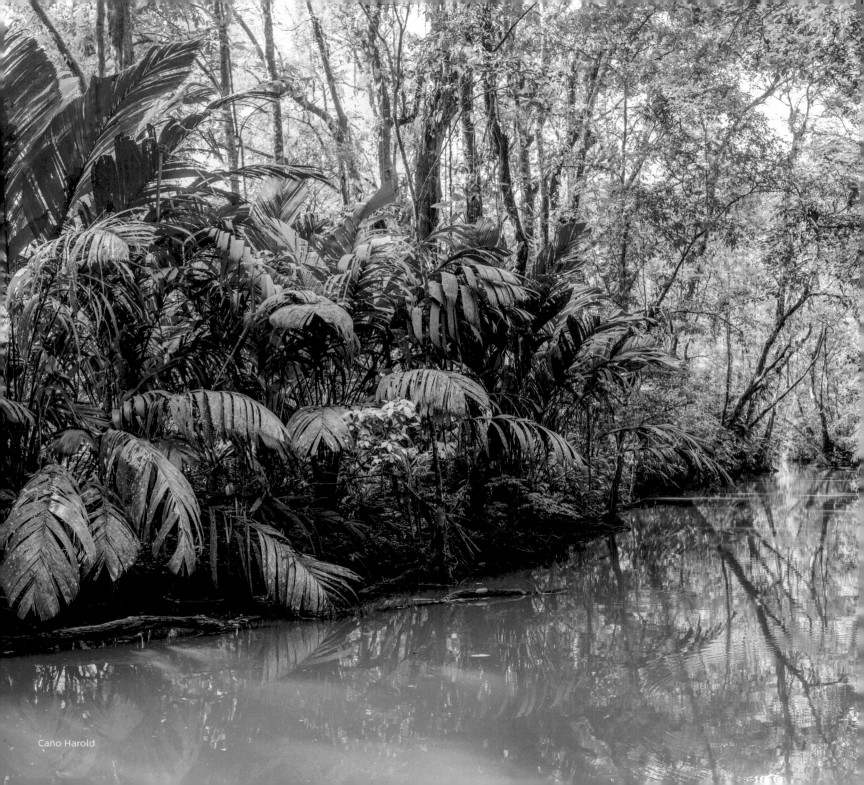

Caño Harold

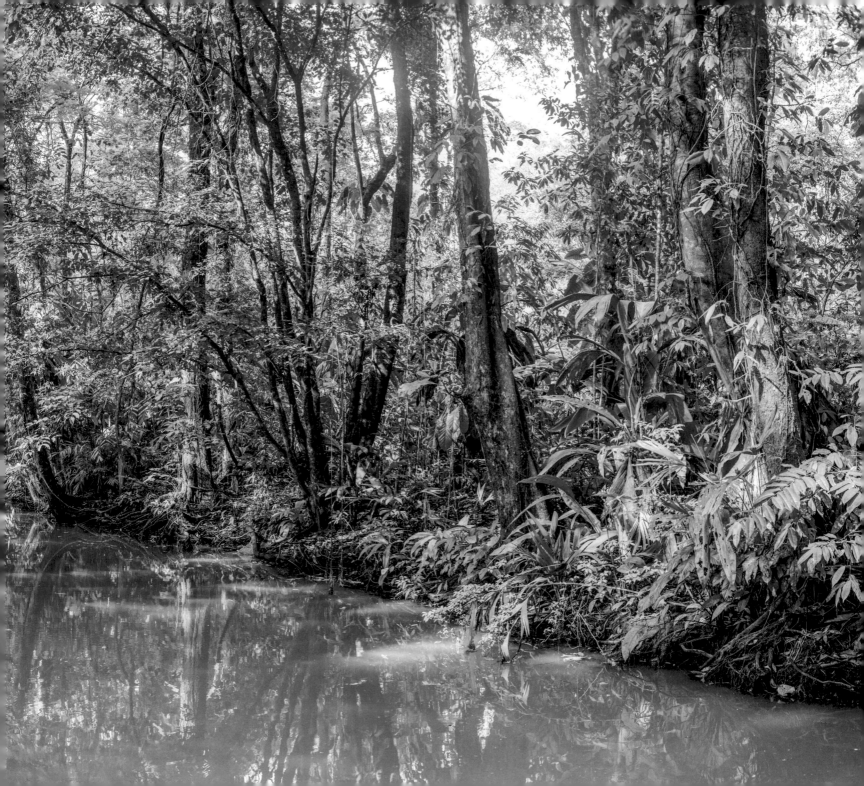

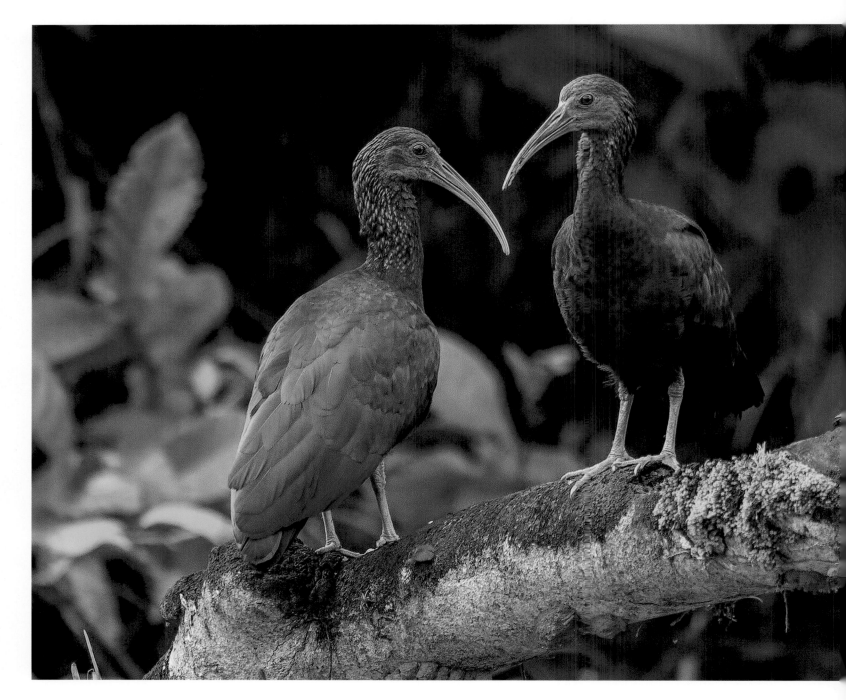

The narrowest canals, such as Caño Harold or Caño Palma, are the best suited for observing wildlife.

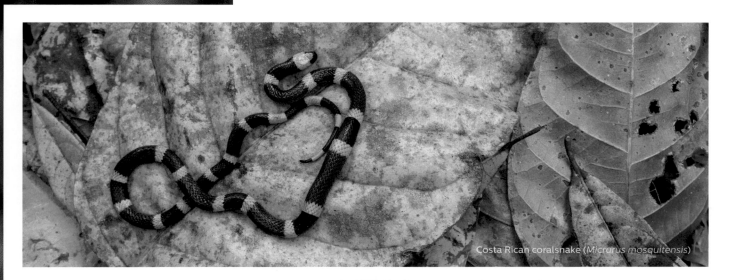

Costa Rican coralsnake (*Micrurus mosquitensis*)

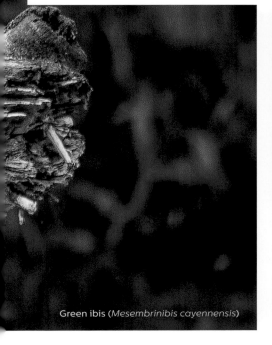

Green ibis (*Mesembrinibis cayennensis*)

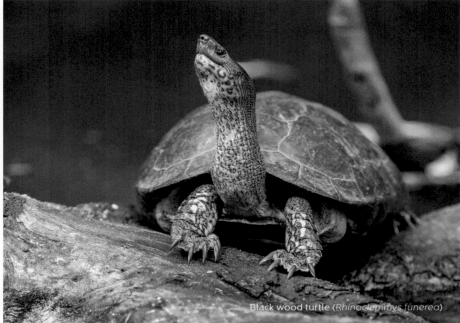

Black wood turtle (*Rhinoclemmys funerea*)

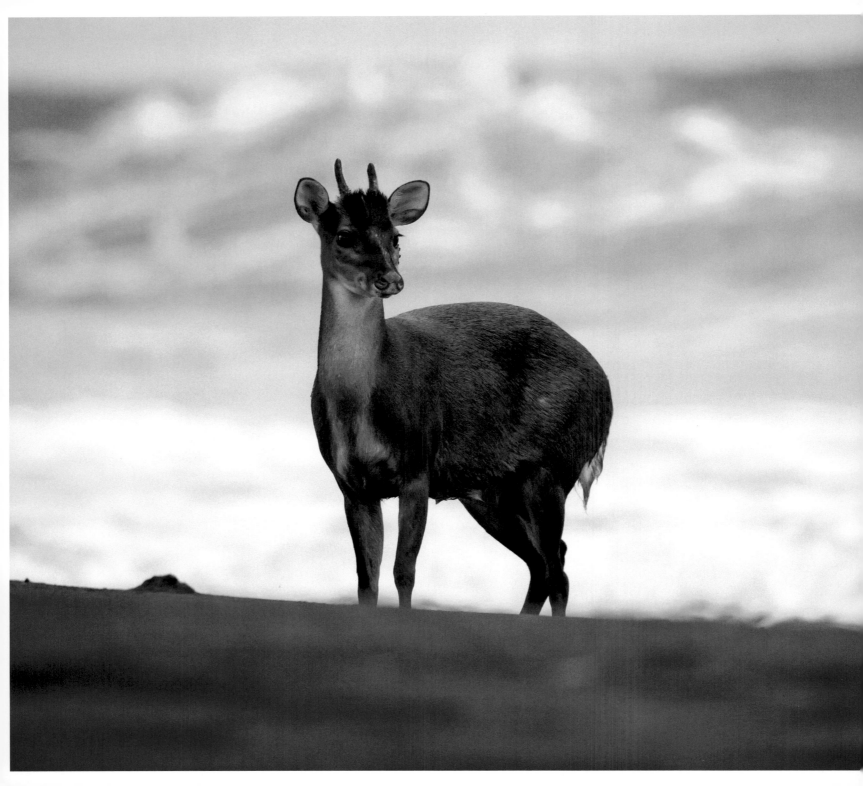

UNEXPECTED
ENCOUNTERS

At dawn, the beaches of Tortuguero can become the perfect setting for unexpected encounters. This Central American red brocket deer (*Mazama temama*), for example, is very shy and difficult to observe, as it prefers to ramble within the very dense vegetation of undisturbed forests. It is one of two species of deer in Costa Rica.

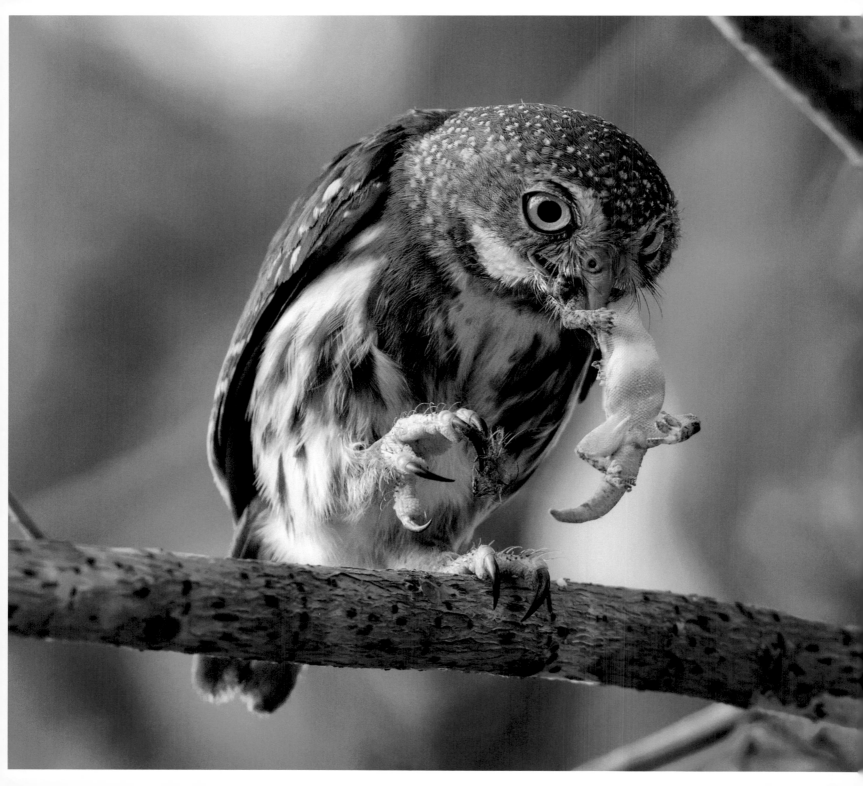

OWLS

The Central American pygmy-owl (*Glaucidium griseiceps*) is the smallest of the four species of pygmy-owl that live in Costa Rica. Despite its threatening appearance, it measures just 5.5 inches (14 cm). It is found only on the Caribbean slope of the country, up to an altitude of 2625 feet (800 m). Unlike most owls, which are usually nocturnal, this species is also active during the day.

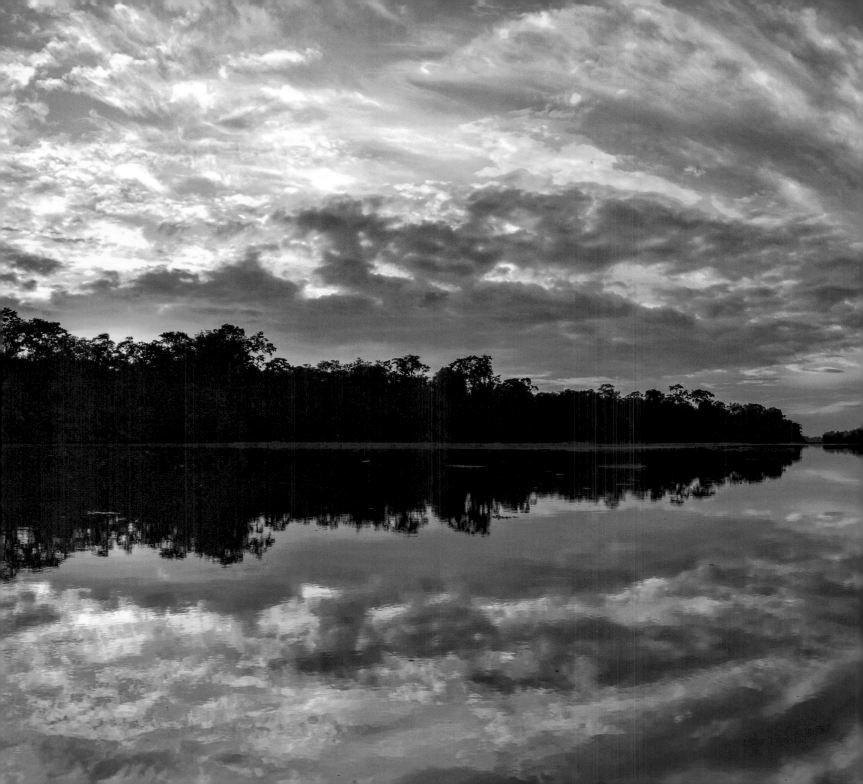

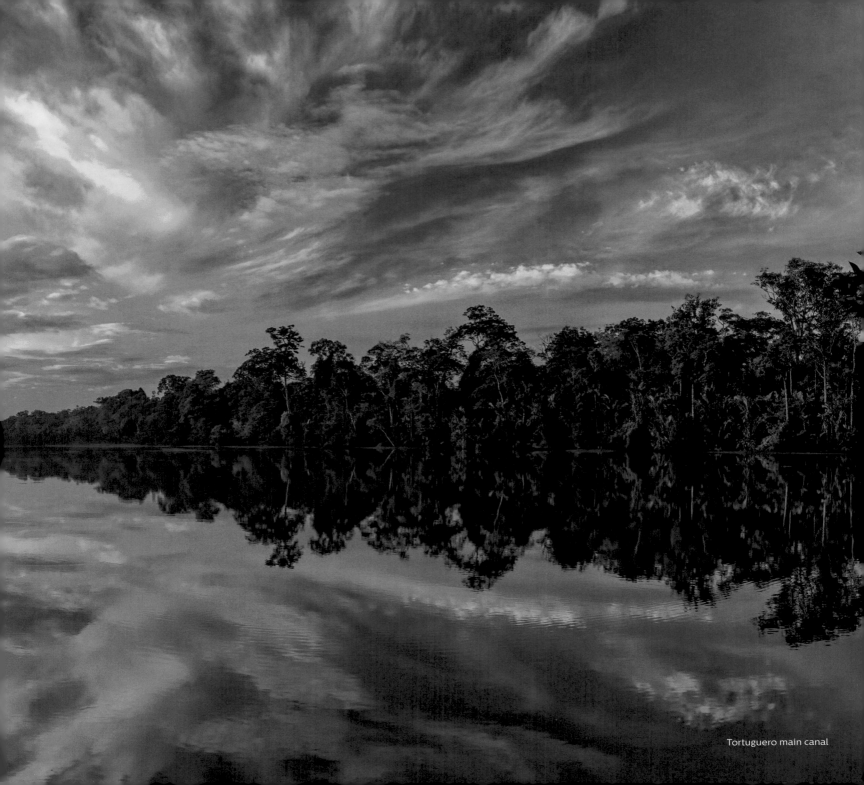

Tortuguero main canal

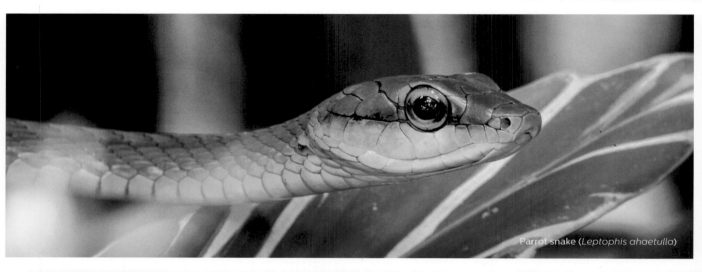

Parrot snake (*Leptophis ahaetulla*)

Common blunt-headed vine snake (*Imantodes cenchoa*)

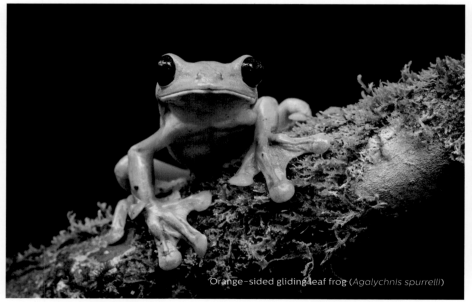

Orange-sided gliding leaf frog (*Agalychnis spurrelli*)

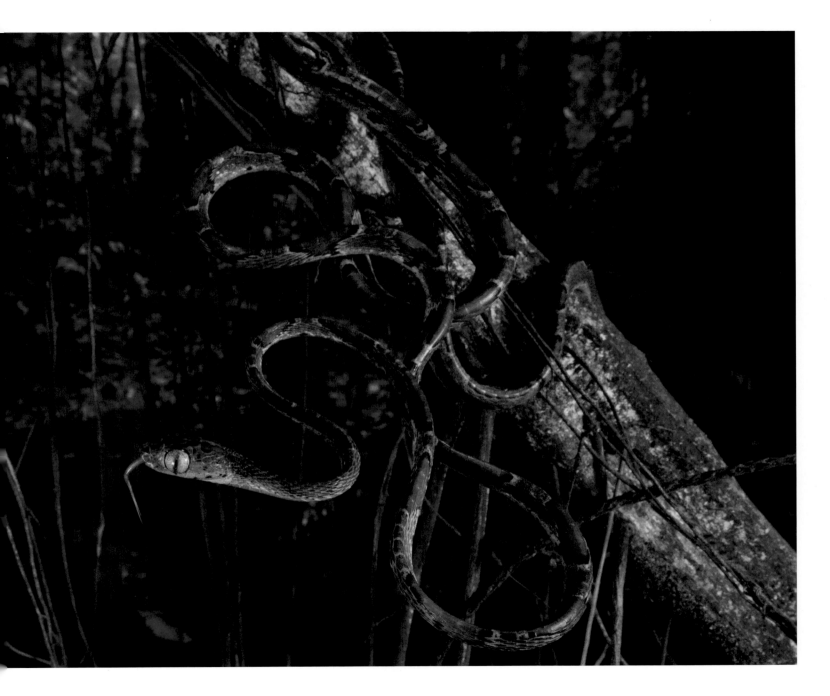

Fifty-six species of amphibian and a staggering 111 species of reptile have been recorded in Tortuguero.

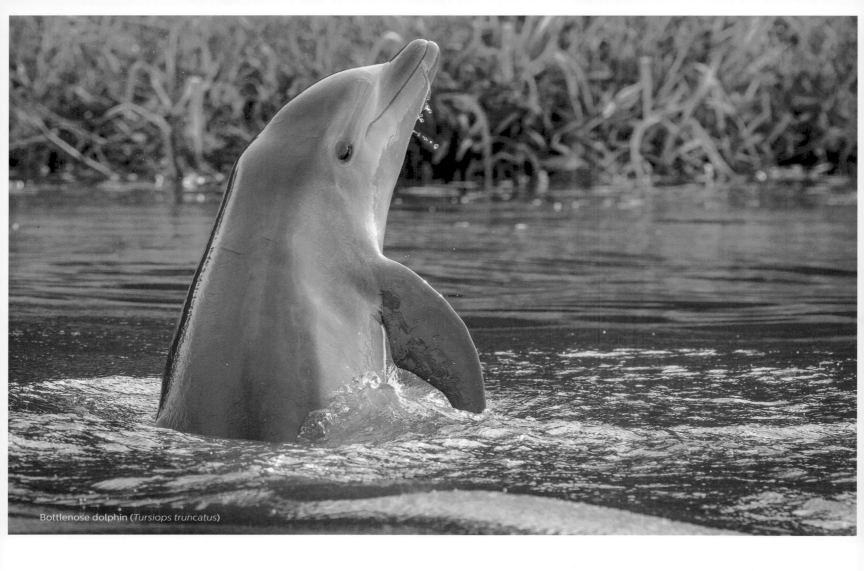

Bottlenose dolphin (*Tursiops truncatus*)

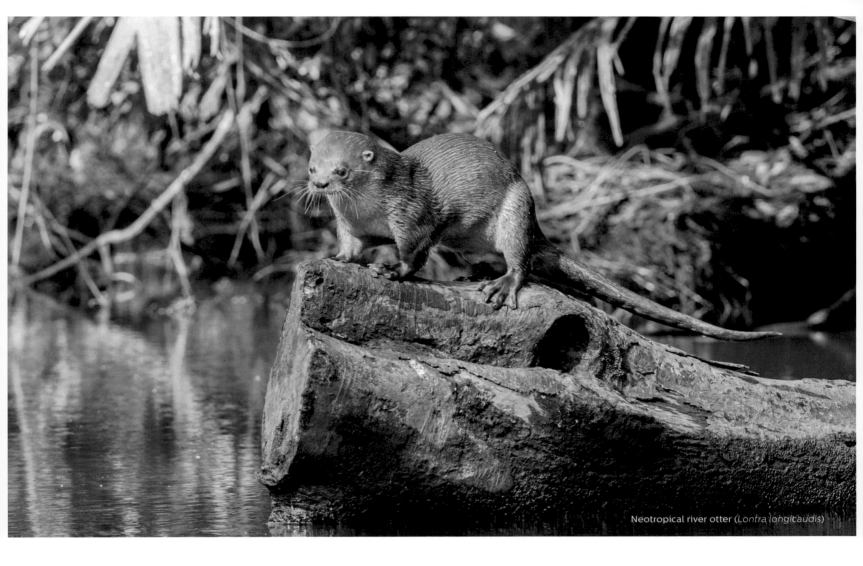
Neotropical river otter (*Lontra longicaudis*)

Although you rarely see them, bottlenose dolphins can live in freshwater lagoons and rivers, and they frequently enter the canals of Tortuguero in search of prey. It is easier to spot otters, as they rest on exposed pieces of wood or hunt in tributary canals. The otter's ability to catch fish was highly esteemed by Talamanca indigenous peoples, who would pass the pelt of an otter over the back of a pregnant woman, a ritual meant to ensure that the unborn child would be a skilled fisherman.

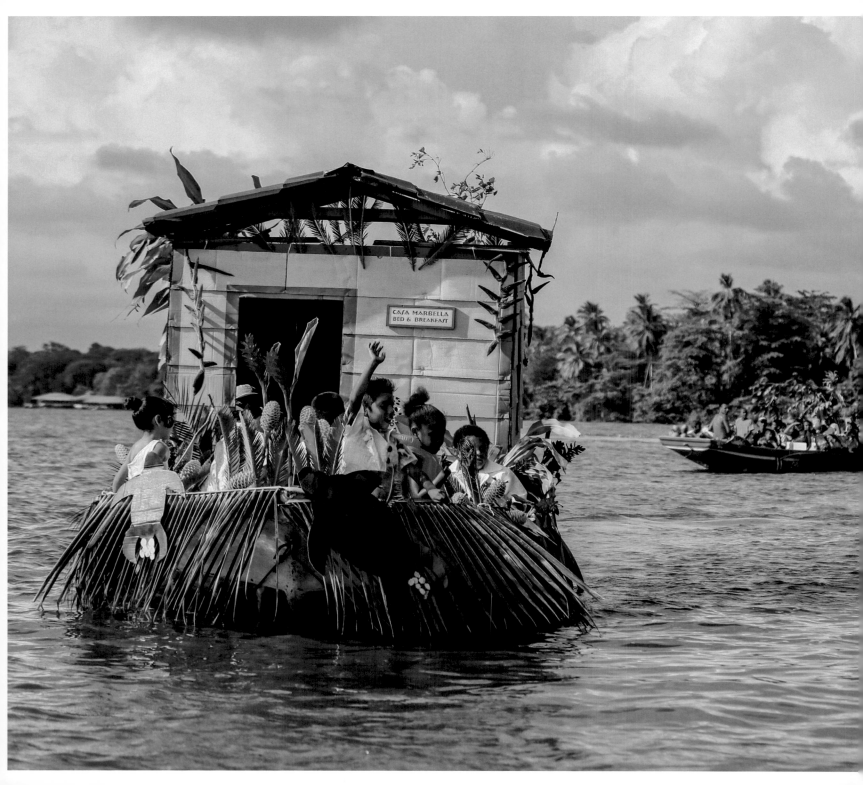

Every year, at the end of October, Tortuguero celebrates the end of the turtle season with music, dance, and boat flotillas. These festivities once served as a way of expressing gratitude for the abundance of food that came with the yearly turtle harvest. Today, the celebration still revolves around the abundance brought by the turtles, no longer with their meat, but with the number of tourists drawn by their presence.

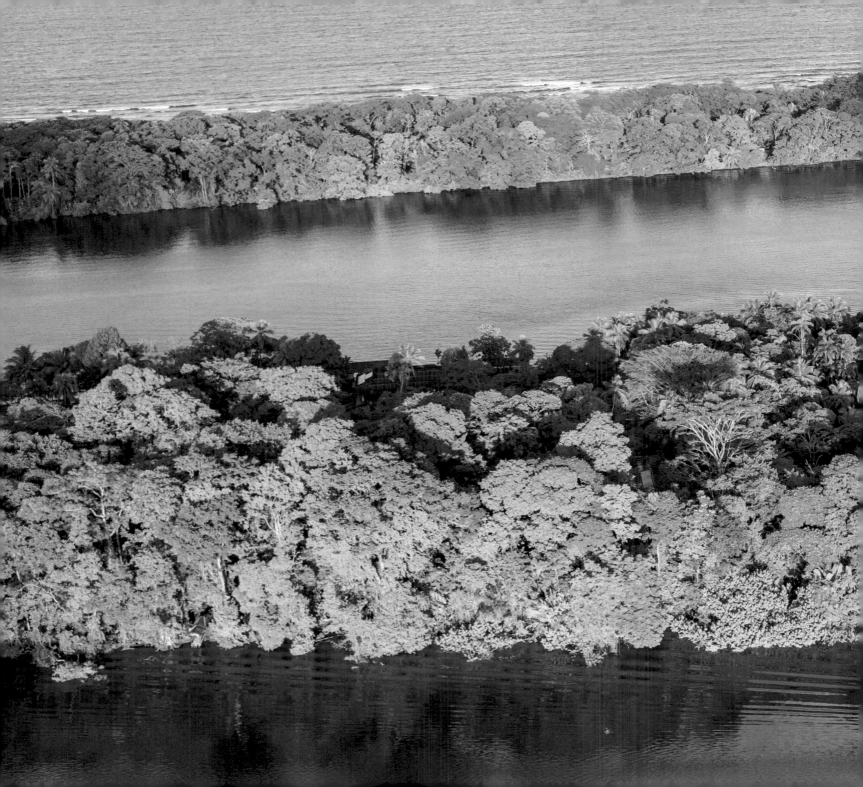

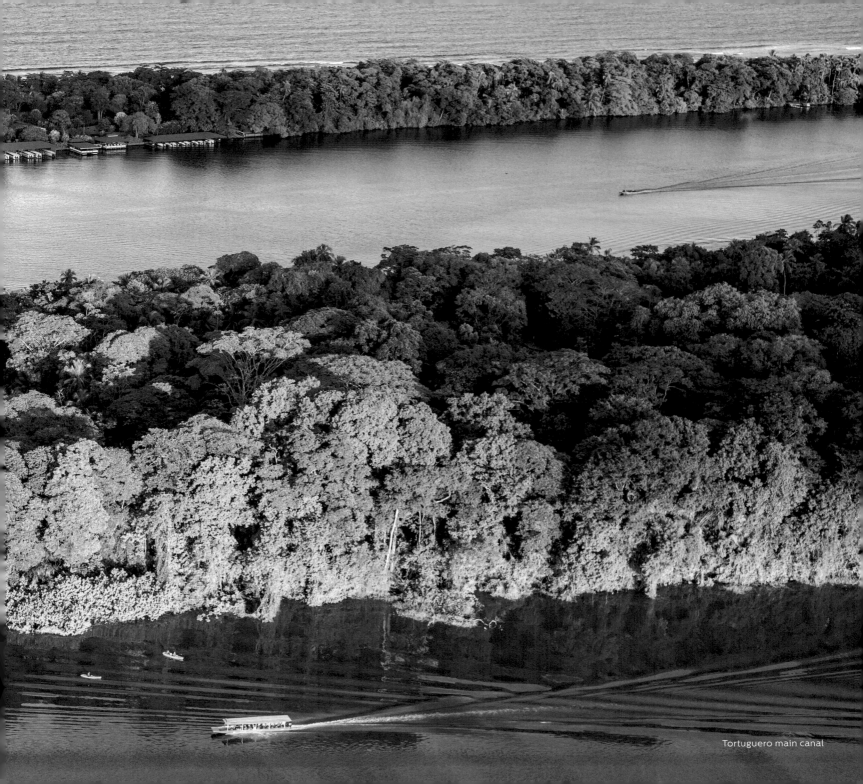
Tortuguero main canal

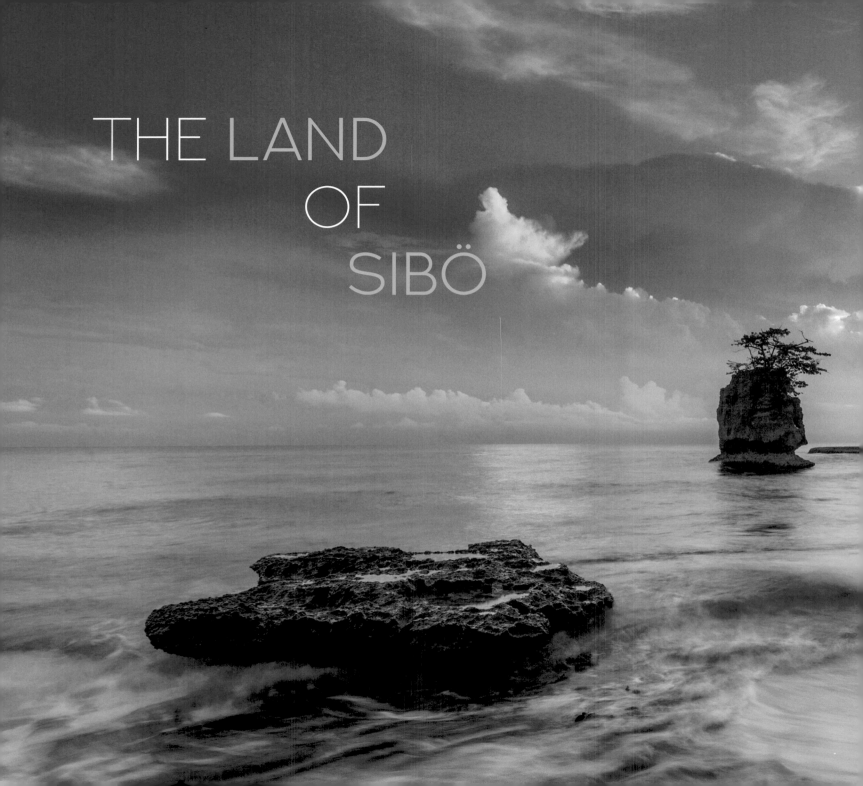

THE LAND OF SIBÖ

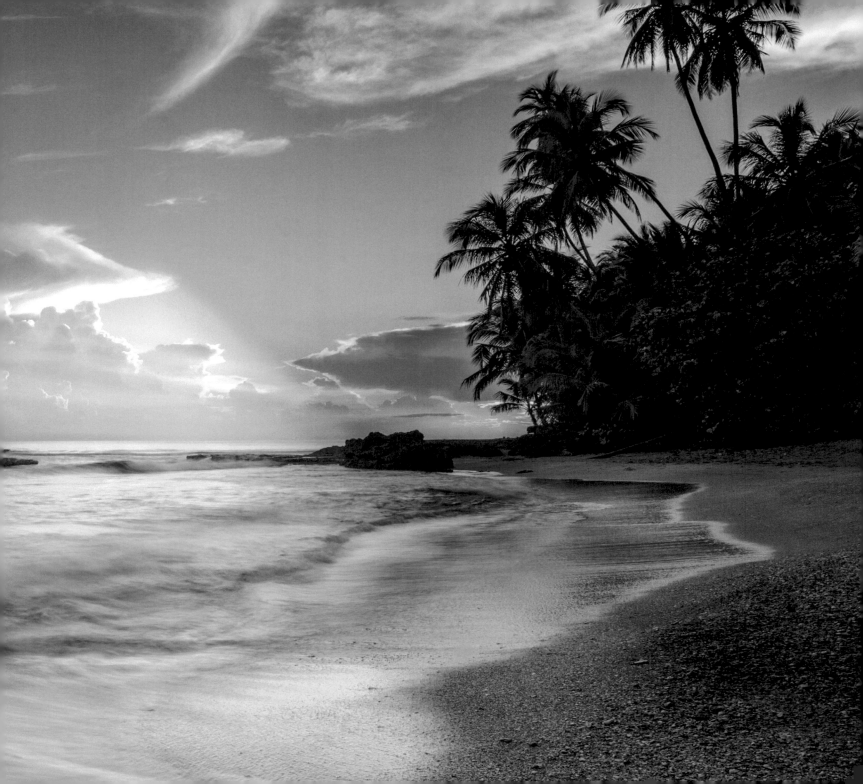

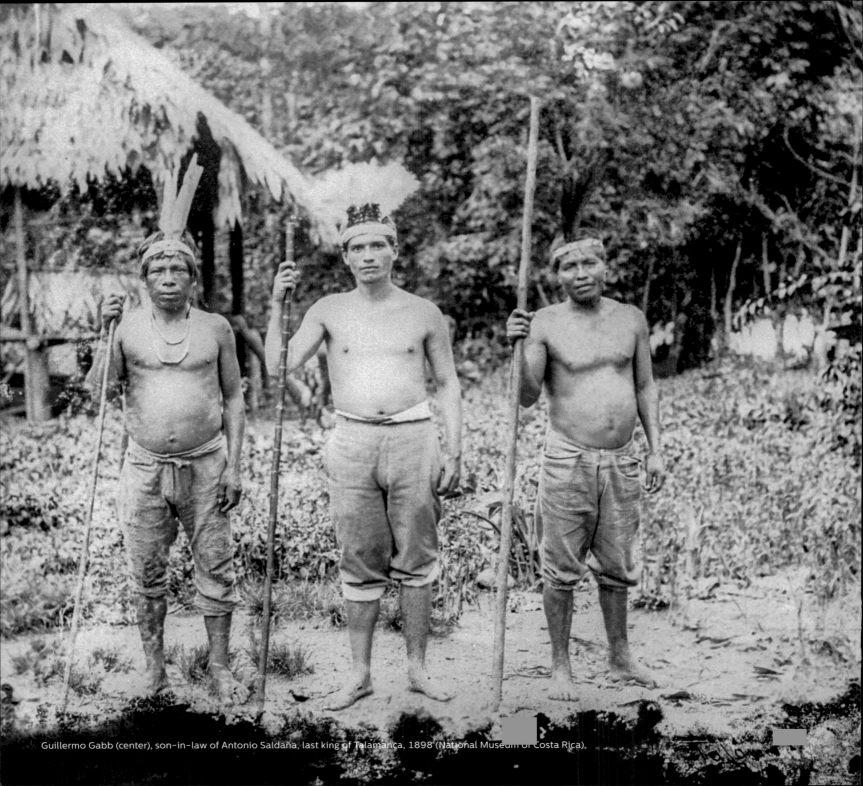

Guillermo Gabb (center), son-in-law of Antonio Saldaña, last king of Talamanca, 1898 (National Museum of Costa Rica).

When the god Sibö created the sea, he also created seeds. And from one seed, planted in lands far away, where the sun rises, the indigenous peoples were born. Sibö then put another seed on a raft and blew the raft so far away it became lost on the seas. From this seed the *Sikuas* were born, foreign people with uniquely colored skin and distinct features who would one day return, brought back by the sea, just like the turtles that come to lay their eggs.

This is why no one was surprised when the Spaniards arrived in the land of Sibö; they were the lost seed that returned upon the ocean waves. The indigenous people also knew that on the other side of the world Sibö had sorted the seeds into different clans and assigned them their jobs. Perhaps this is why the clan of the sailors came looking for the place where Sulá, lord and master of the underworld, had hidden his gold.

The hopes and dreams conjured up by the name *Costa Rica*, or "Rich Coast," combined with the myth that the Talamanca Mountains held more gold than the Potosí mines in Peru, were a magnet for seekers of gold, oil, and other mineral wealth, who would continue to arrive for hundreds of years.

The indigenous peoples never imagined that gold, which the tribes from the south had taught them could be molded using the "lost wax" technique, would cause the descendants of the *Sikuas* to become so cruel. The clan of the sailors was followed by the clan of the explorers and then by the clan of the settlers, trailed by the missionaries, the kidnappers of indigenous people, the geologists, the adventurers, and, once again, the missionaries.

"The Indians here never knew about Columbus. It was just recently, when we learned how to read, that we found out about his passing through Limón. For us, the point of contact with the white men was through the missionaries. They came to baptize, marry, and convert us, beginning around the year 1600," relates Juanita Segundo from her home in the Bribri territory of Kekoldi, a few miles from Puerto Viejo.

"They chopped down all the existing forests in Sixaola, Sepeque, Chase, and Orúchiko to plant banana and put in the railroads. They committed many abuses against the Indians," adds her mother, Catalina Morales.

The Bribri is the most numerous indigenous group in Costa Rica, with some 10,000 individuals, and the one that has best preserved its traditions. At one point, they lived throughout the southern Caribbean, but they were later displaced to the mountains, fleeing from the abuses of the Spaniards and, later, from the depredations of the banana company. Only a few communities survive in the lowland areas: Amubri, Suretka, and the small town of Kekoldi.

Of the three, Kekoldi lies closest to the ocean, in a steep area a few miles from Puerto Viejo, at a place where the vast Caribbean flatland spreads out like a funnel and the great Talamanca Mountains sink into the sea. This flat region, which is just a few miles wide, lies between the intense blue waters of the Caribbean and the brilliant green forests of the largest protected area in Costa Rica, Amistad National Park. Over it, each year, funneled between the mountains and the sea, fly three and a half million raptors as they migrate from the northern continent toward South America.

Gliding to reduce the expenditure of energy, thousands of vultures, hawks, falcons, and ospreys take advantage of every ascending current to smoothly

climb up to the next current in a spiraling path. When night catches up with them, the migration ceases and the birds take shelter in the trees of Puerto Viejo and Cahuita until the sun returns to warm up the air, making it possible for them to continue their journey.

In contrast with the raptors that are passing through, the people that arrive to this area often come to stay, among them immigrants from Jamaica and China.

"My grandfather and many of his relatives went by boat from Hong Kong to Los Angeles. From there they went to Jamaica, although I don't know by what route. When they reached the coast of Limón, the boats would come near to the shore and the sailors would put the immigrants into wooden barrels so they wouldn't drown. They would land in Matina, because they were entering illegally," says Manuel León Salazar, perhaps the best-known Chinese descendant in Puerto Viejo. He describes how Chinese immigrants were smuggled into Costa Rica at the start of the 20th century to provide labor for the building of the railroad and the port and to work in the banana plantations.

The colonial port of Matina, which once had attracted the attention of pirates, became a temporary home for hundreds of Chinese immigrants looking to establish themselves in this new land. "They would stay there for five or six years, until they could get papers."

The Jamaicans arrived to Limón at the same time as the Chinese and with them came the first Protestant churches. The Baptist church was opened in 1888, the Methodist in 1894, and the Anglican a year later. From the start, the churches played an active role in education and in the transmission of cultural and linguistic values.

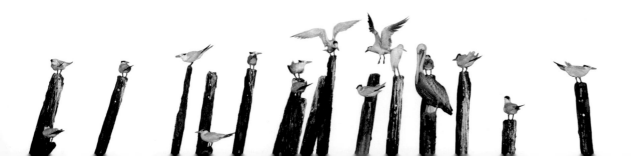

Even the Catholic church in Limón has developed a different profile in the country, offering masses in English. Among the various religious denominations in the region, one notes a great deal of fellow feeling and tolerance. And there has been a resurgence of interest on the part of local youth to attend services and join choirs. Some amazing voices can be heard in religious services as well as outside of them.

Walter Gavitt Ferguson, a favorite son of Limón, discovered he had a gift for music at the age of 24, when he improvised a few lyrics in the town's *pulpería* (or local store) and someone grabbed a guitar to accompany him.

Hovering between humor and tragedy, he could seemingly pick songs out of thin air. Judging by the smiles on people's faces, the applause, and the dancing, he figured the gift was working. "I'll tell you, in my day, I drove all of Cahuita crazy," he says.

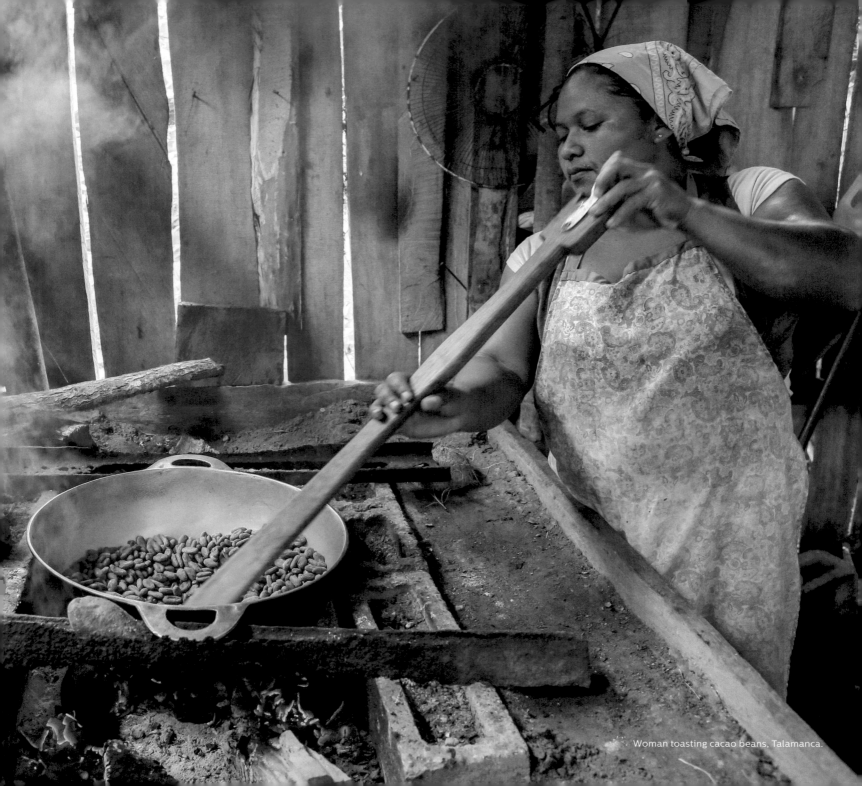

Woman toasting cacao beans, Talamanca.

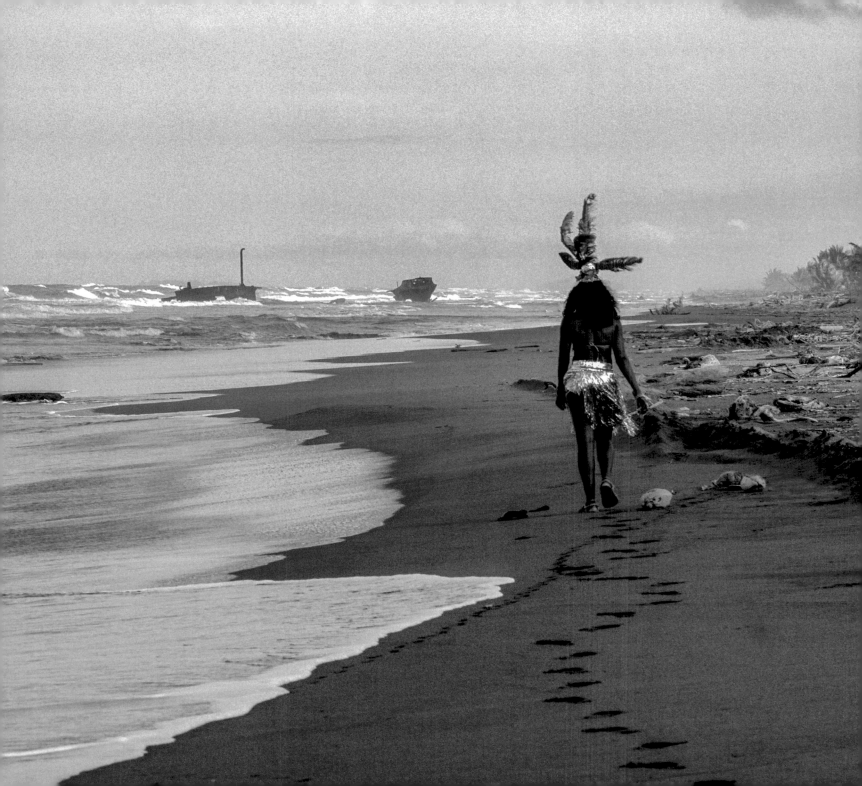

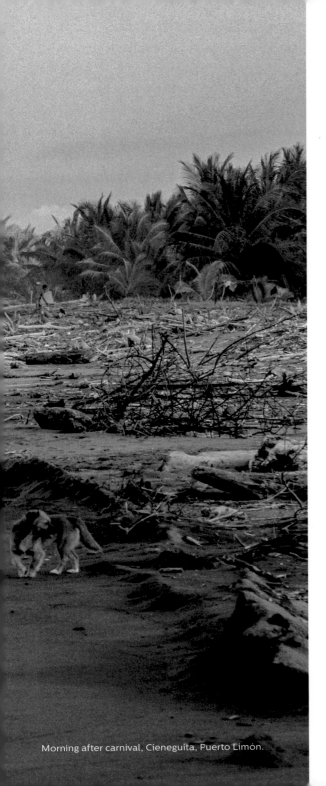

Morning after carnival, Cieneguita, Puerto Limón.

A neighbor of Cahuita National Park, whose intact tract of tropical rainforest and underwater coral gardens attracts tourists, Walter Ferguson has written over 80 songs and is widely considered Costa Rica's greatest calypso composer.

You can hear his songs being hummed by the local women as they walk down the street, in restaurants where dishes made from coconut milk are eaten as people listen to his eternally young voice on a rough-sounding homemade cassette tape, or played by bands in the local bars, the singers often unaware of who wrote the song.

Born in Guabito, Panama, in 1919, Ferguson has avoided playing in public for 40 years, though he still composes and plays. Dedicated full-time to his church, Ferguson still strums out familiar calypso chords on his old guitar when the sun goes down and the howler monkeys return from their deep-forest excursions.

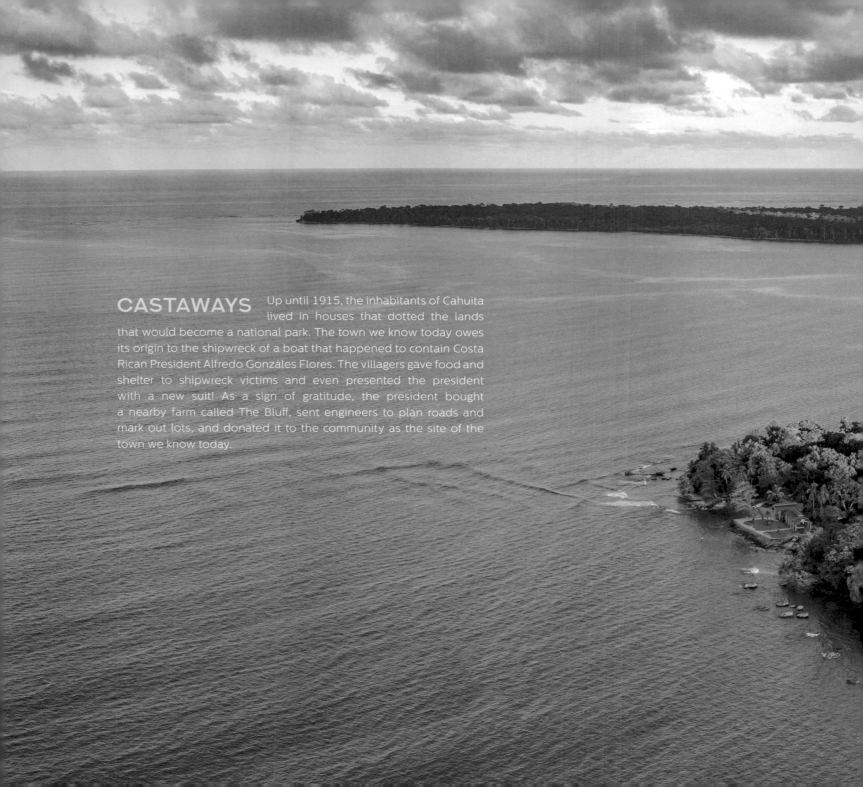

CASTAWAYS

Up until 1915, the inhabitants of Cahuita lived in houses that dotted the lands that would become a national park. The town we know today owes its origin to the shipwreck of a boat that happened to contain Costa Rican President Alfredo Gonzáles Flores. The villagers gave food and shelter to shipwreck victims and even presented the president with a new suit! As a sign of gratitude, the president bought a nearby farm called The Bluff, sent engineers to plan roads and mark out lots, and donated it to the community as the site of the town we know today.

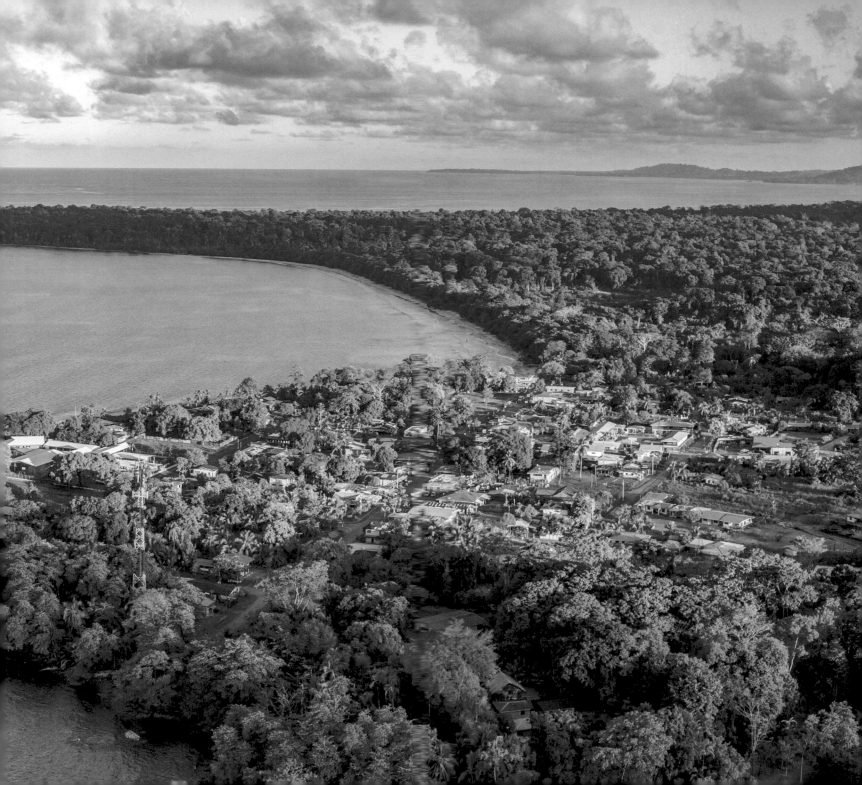

A CORAL FAN

Cahuita National Park is justly famous for its reef, the largest and best-preserved on the Caribbean coast of the country. In the waters off Punta Cahuita, lies a fan-shaped formation of some 1500 acres (600 hectares), nestled between Perezoso River and Puerto Vargas. In 1991, an earthquake of magnitude 7.5 caused the reef platform to rise almost 3 feet, leaving a large shelf of coral that is exposed at low tide.

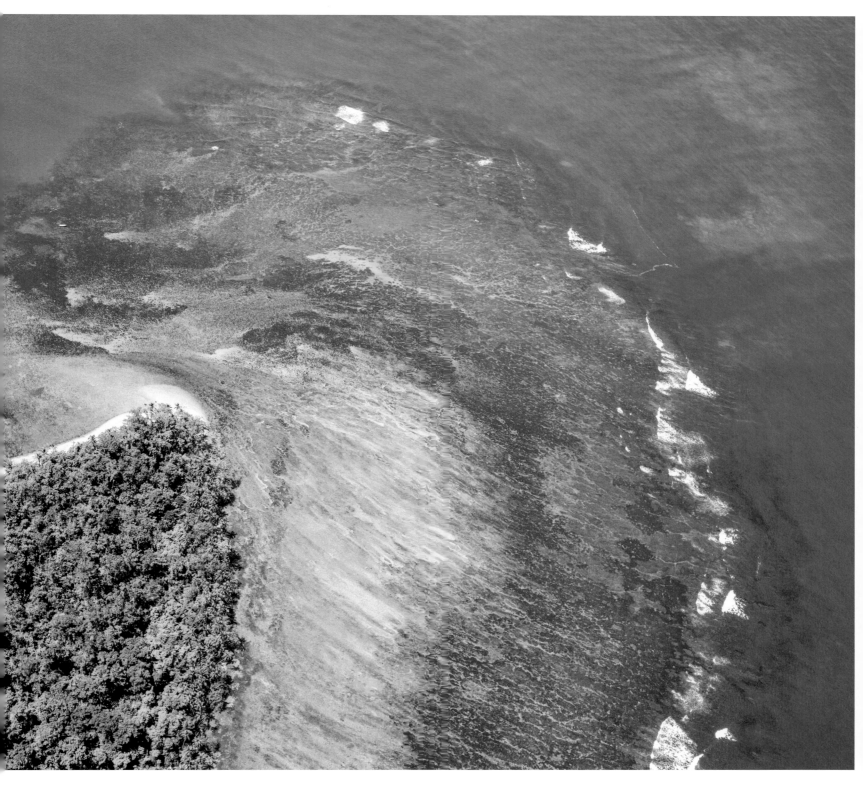

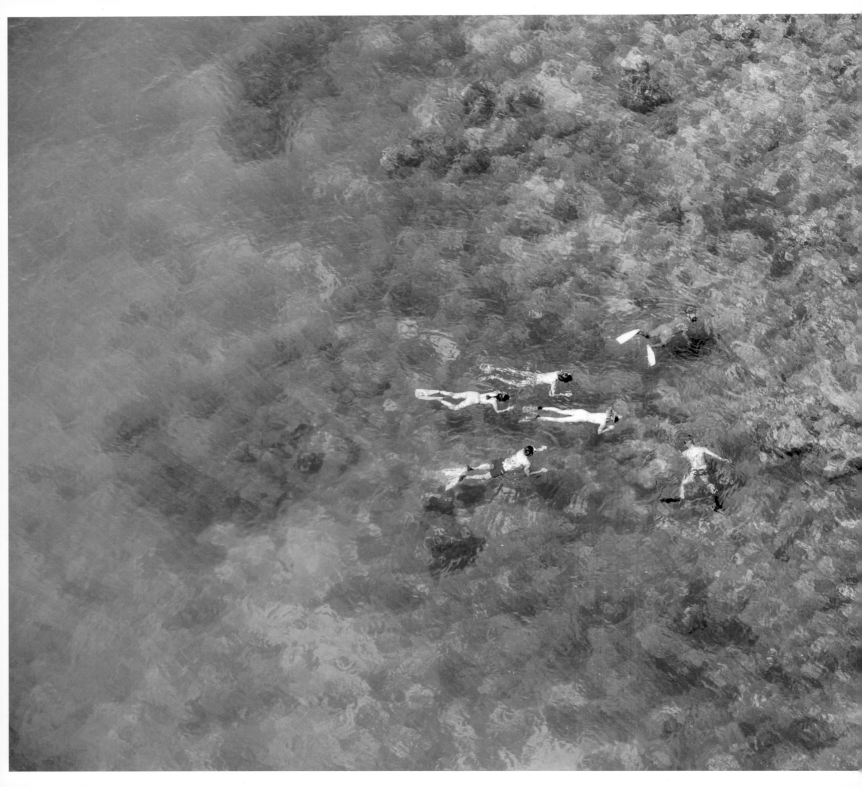

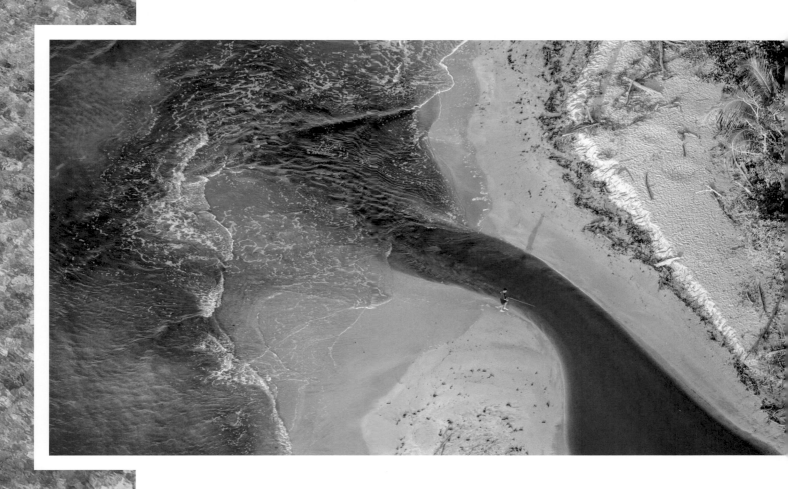

What is perhaps most striking about the southern Caribbean are its vibrant colors. Fallen trees disintegrate in these stagnant streams and the tannin in their bark stains the water with the color of tea. The hues of the sea vary from intense greens to celestial blues. The same colorful show takes place underwater, were fish and coral of many colors and shapes abound

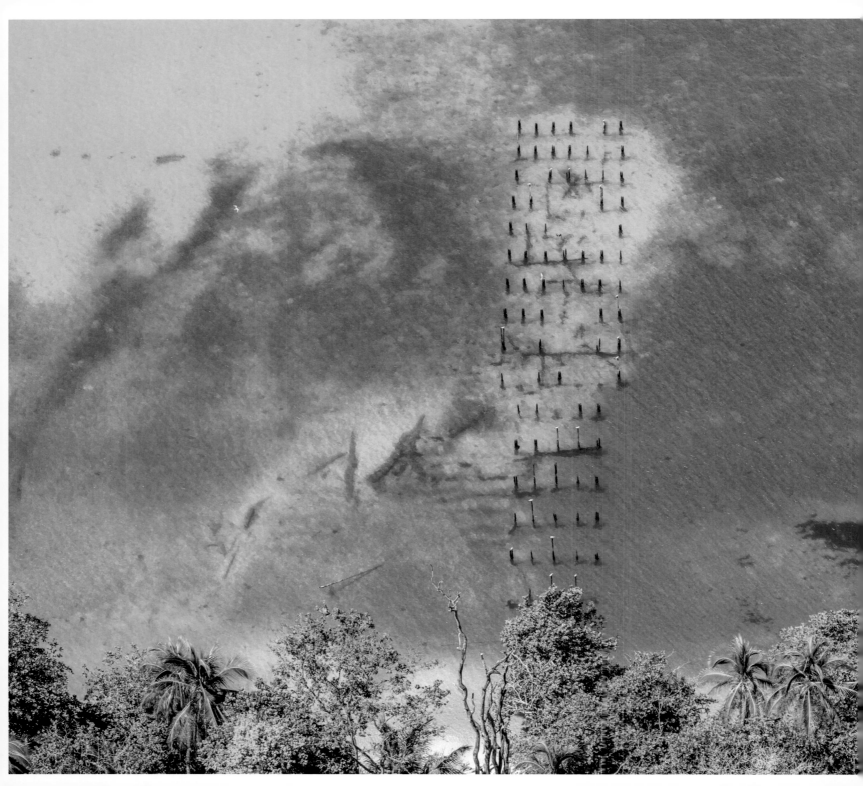

In 1930 the city of Limon built a dock near the Perezoso River so that the villagers could transport their products to the city. Today, the only thing that survives of the dock are worm-eaten poles that serve as resting places for birds.

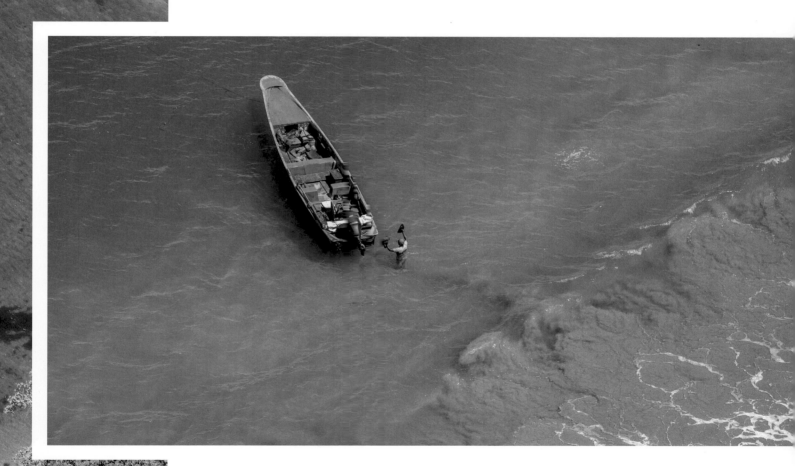

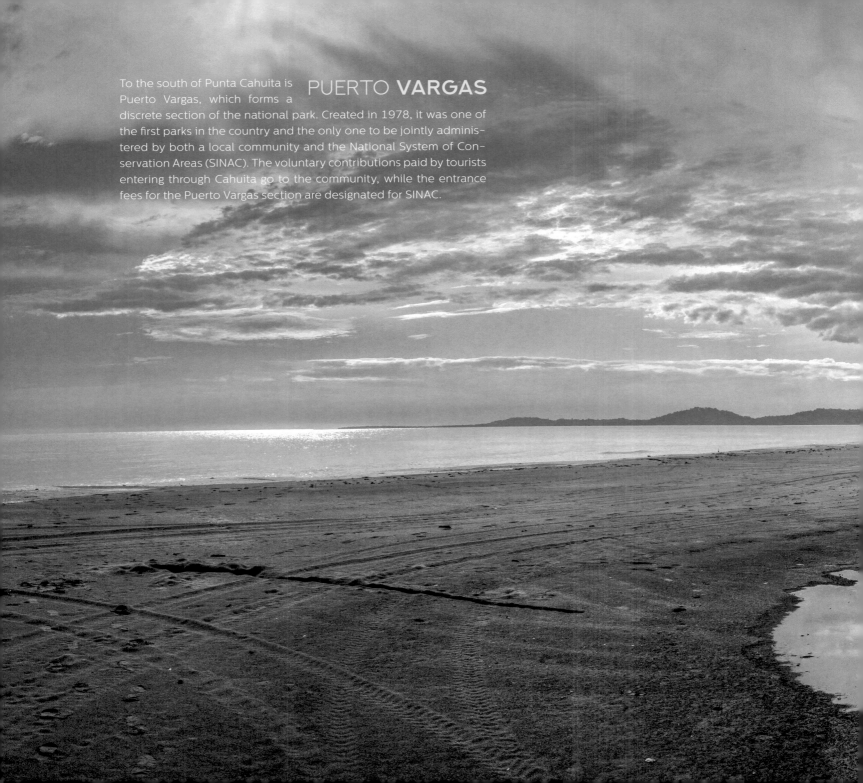

PUERTO **VARGAS**

To the south of Punta Cahuita is Puerto Vargas, which forms a discrete section of the national park. Created in 1978, it was one of the first parks in the country and the only one to be jointly administered by both a local community and the National System of Conservation Areas (SINAC). The voluntary contributions paid by tourists entering through Cahuita go to the community, while the entrance fees for the Puerto Vargas section are designated for SINAC.

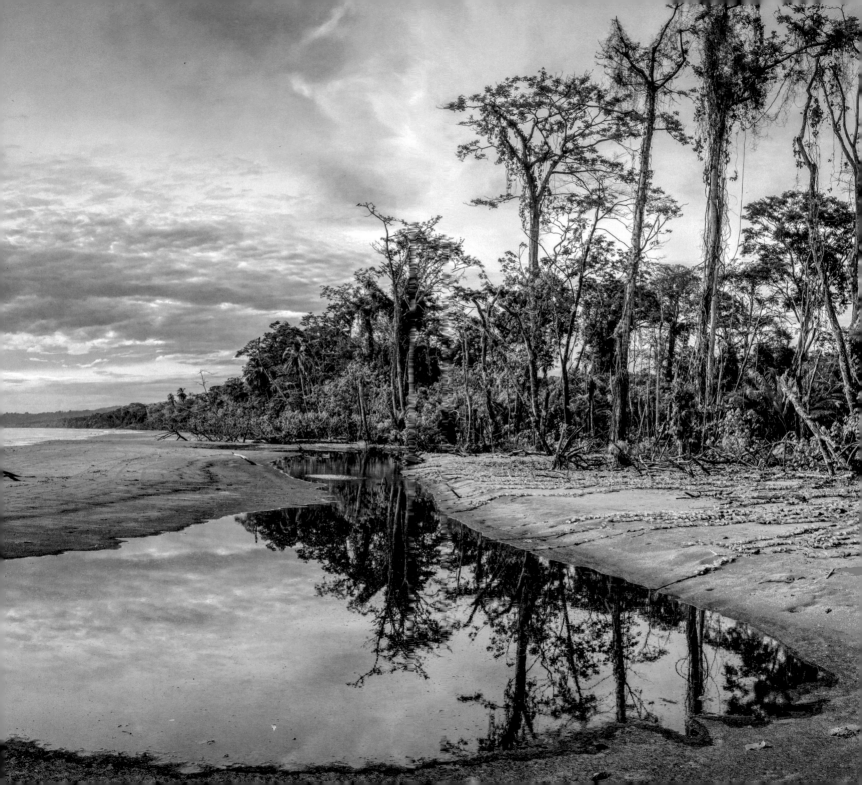

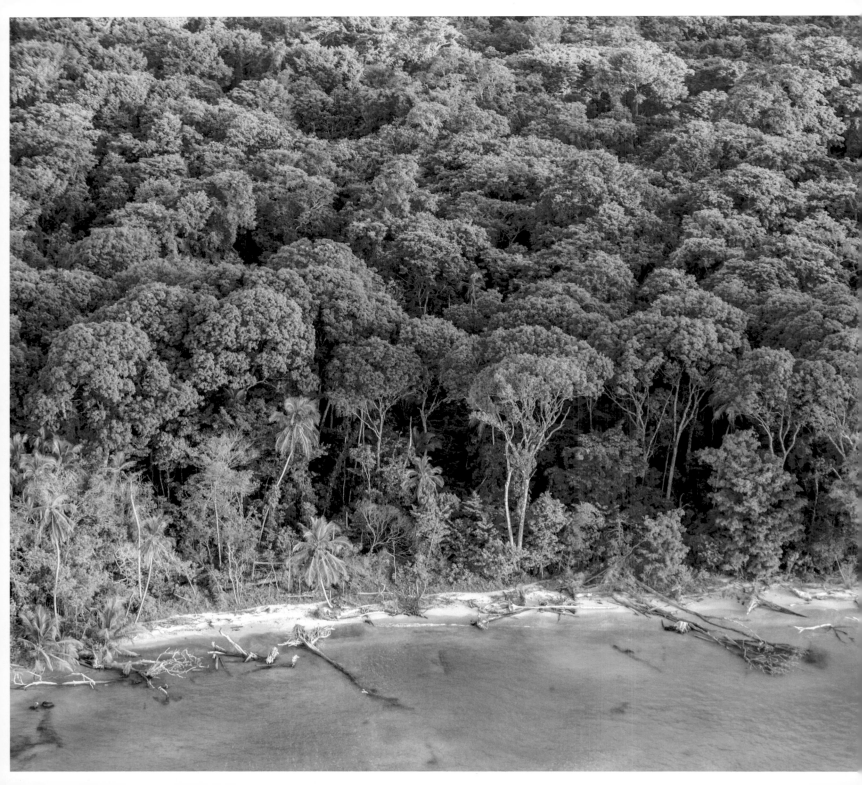

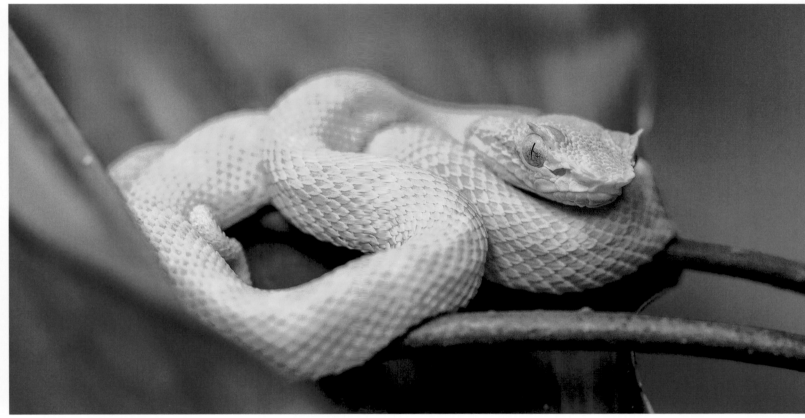

The eyelash palm-pitviper (*Bothriechis schlegelii*) is one of the most beautiful snakes in the Neotropics. Its colour varies greatly depending on where it is found. Red, brown, green, even pink individuals have been recorded, though perhaps none is so spectacular as the yellow form (known locally as the *oropel*), which lives in lowland areas of the Caribbean. Cahuita National Park is the only place in the country where you are virtually guaranteed to see it.

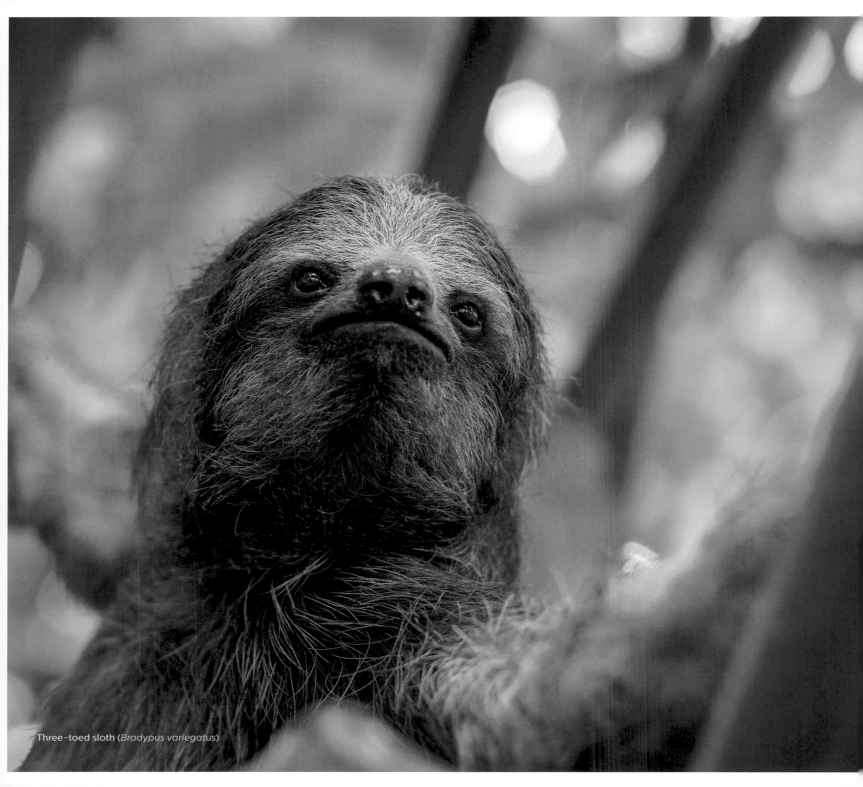
Three-toed sloth (*Bradypus variegatus*)

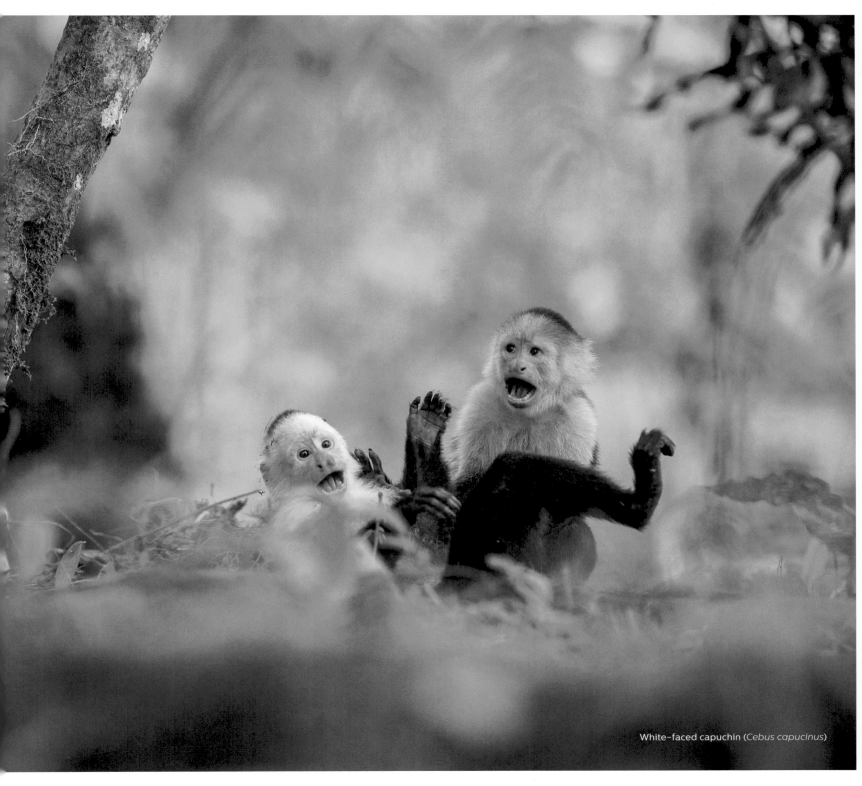

White-faced capuchin (*Cebus capucinus*)

PLAY OF LIGHT

The light in the southern Caribbean has a peculiar quality, most likely due to the near constant humidity in the air. What photographers refer to as "the golden hour," the moments in the morning and evening ideal for capturing great images, seems to extend here for additional minutes. And, the proximity of the sea to the Talamanca Mountains, behind which the sun hides very early, results in shadows and a play of lights that lend an enchantment to the place, one rarely encountered elsewhere.

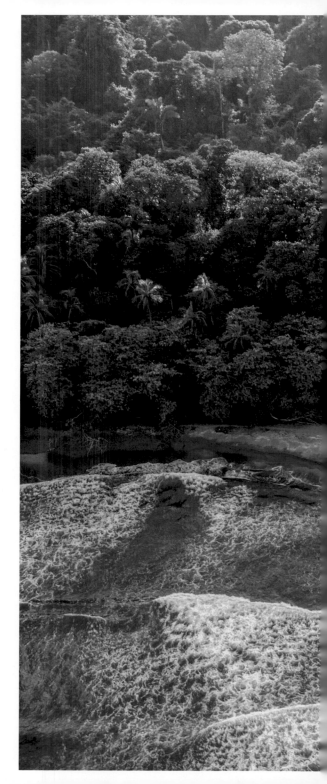

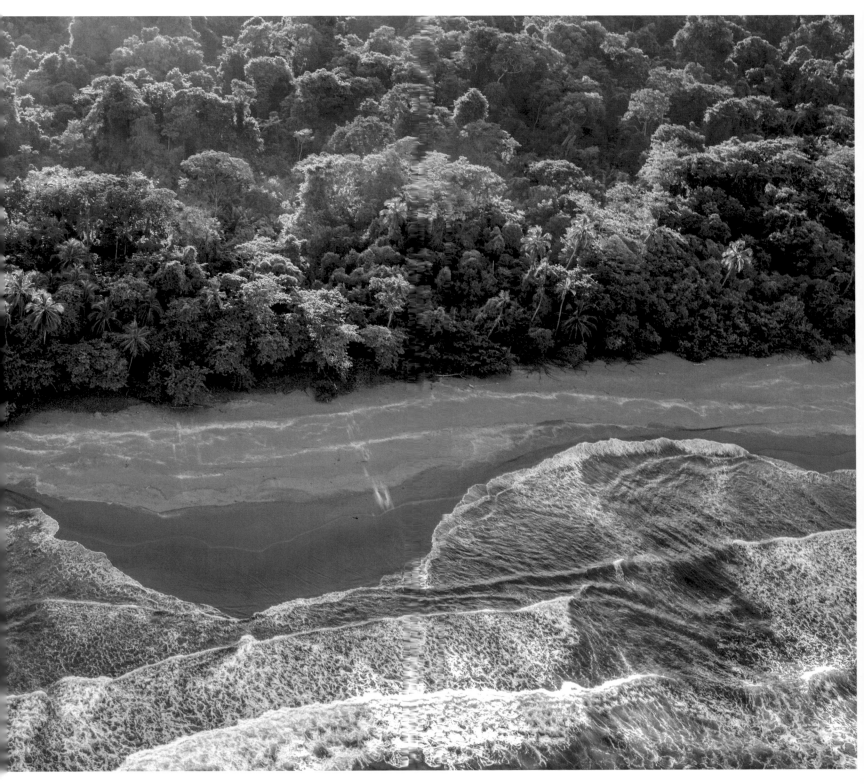

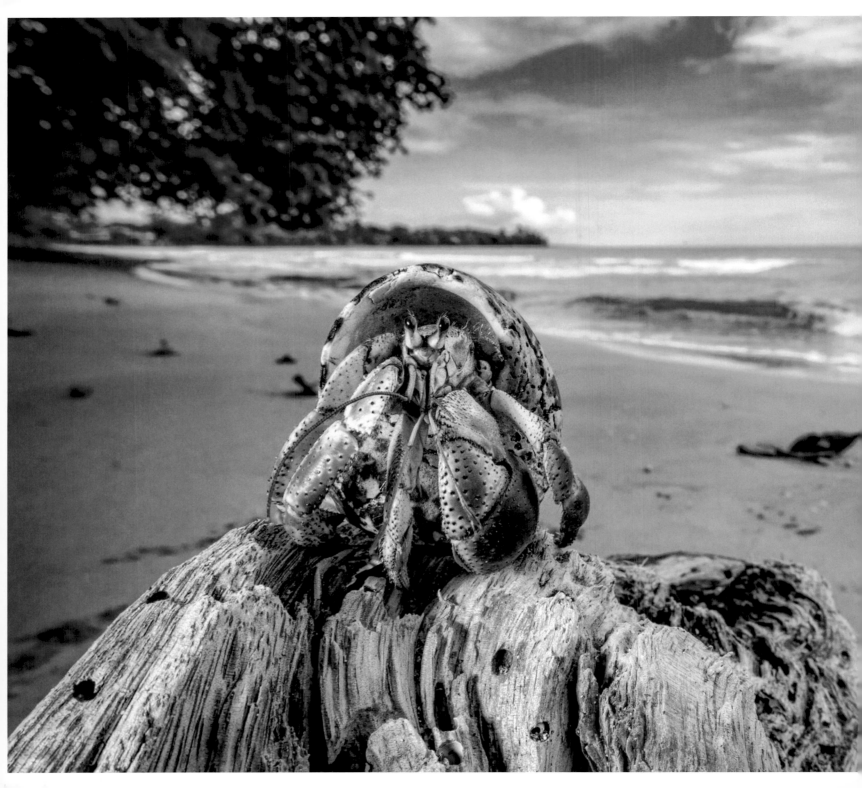

CRABS

Hermit crabs (superfamily Paguroidea) not only reuse shells abandoned by other critters, they also play an important role in the ecology of beaches. They are trash collectors, in a sense, devouring whatever organic matter they come upon. When they become bigger and outgrow their current shell, they will absorb water in great quantities (up to 70% of the volume of their body), inflate themselves, and break apart their shell. They then search for a new shell, one appropriate for their larger size.

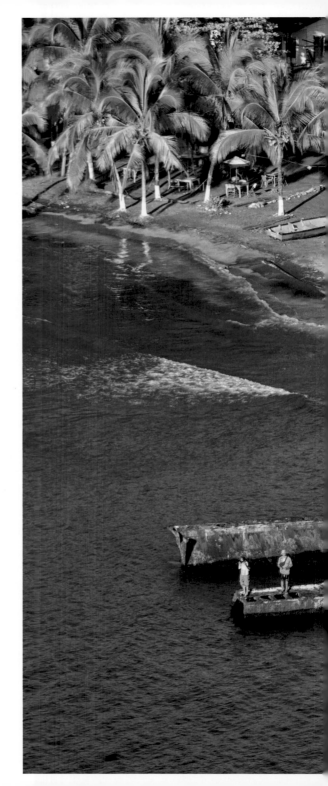

TROPICAL EXUBERANCE

This barge, first used on the construction of the Panama Canal, at the beginning of the 20th century, was transported to Puerto Viejo to carry precious loads of timber to the port city of Limón. No longer in use, it has become an iconic symbol of the town. The almond tree that miraculously took root on the barge lends a feeling of tropical exuberance to the place.

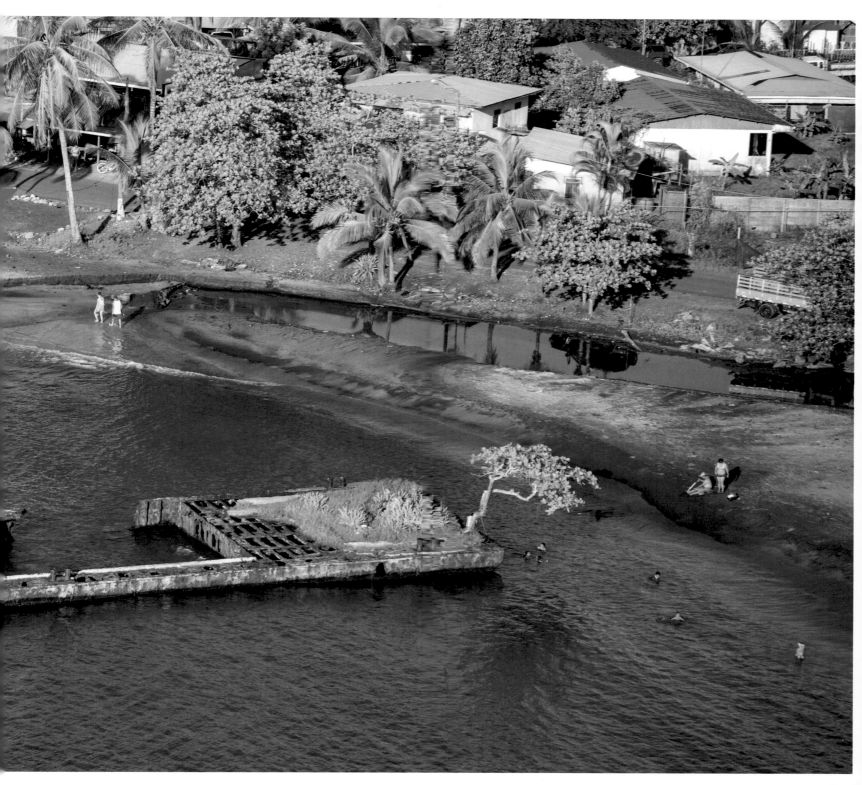

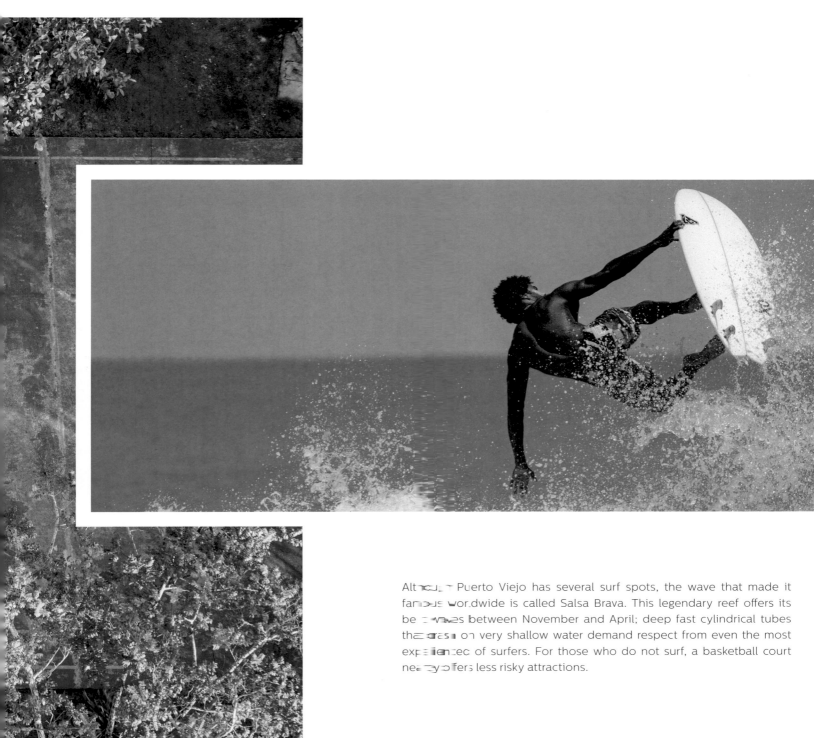

Although Puerto Viejo has several surf spots, the wave that made it famous worldwide is called Salsa Brava. This legendary reef offers its best waves between November and April; deep fast cylindrical tubes that crash on very shallow water demand respect from even the most experienced of surfers. For those who do not surf, a basketball court nearby offers less risky attractions.

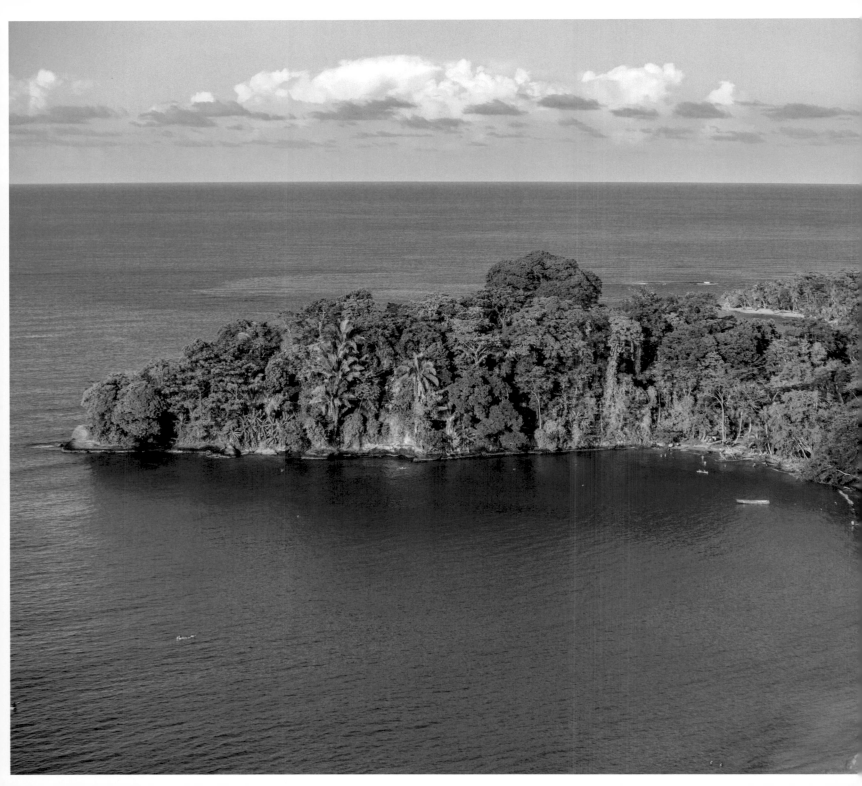

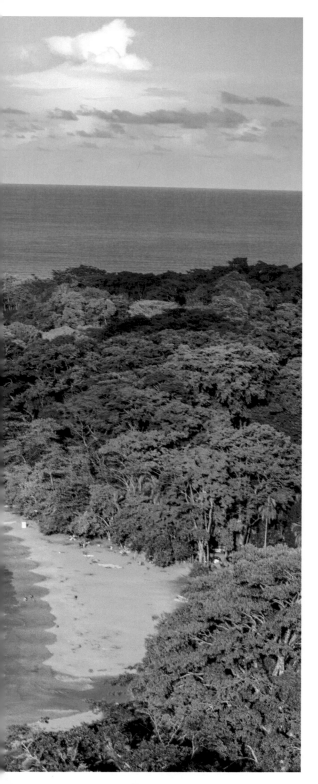

GRAPE POINT

Punta Uva owes it name to the quantity of sea grape plants (*Coccoloba uvifera*) that adorn the region. The point itself is a rock promontory that looks down on a charming bay below whose waters lies an extensive coral reef with enviable biological riches. Two golden-sand beaches, one on each side of the point, give way to jungles with sections composed of primary forest. They are ideal spots for hiking and birdwatching.

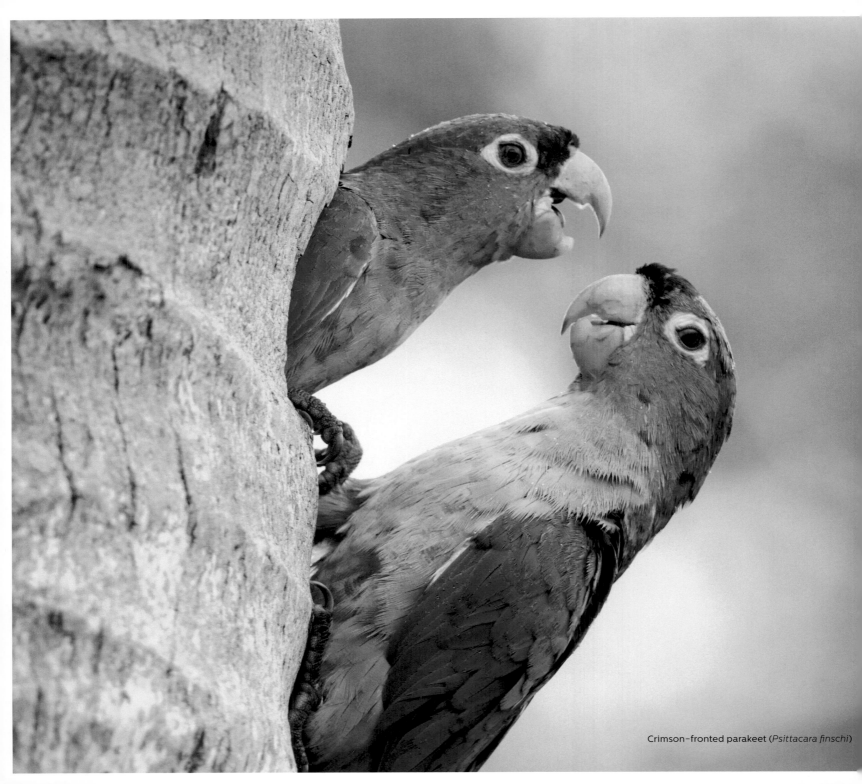

Crimson-fronted parakeet (*Psittacara finschi*)

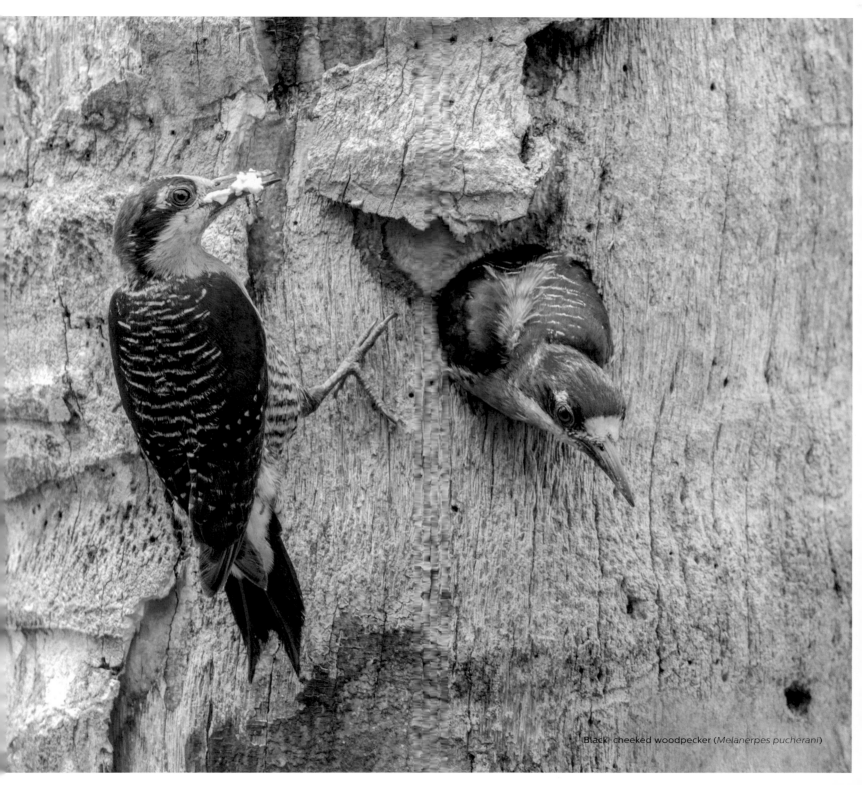

Black-cheeked woodpecker (*Melanerpes pucherani*)

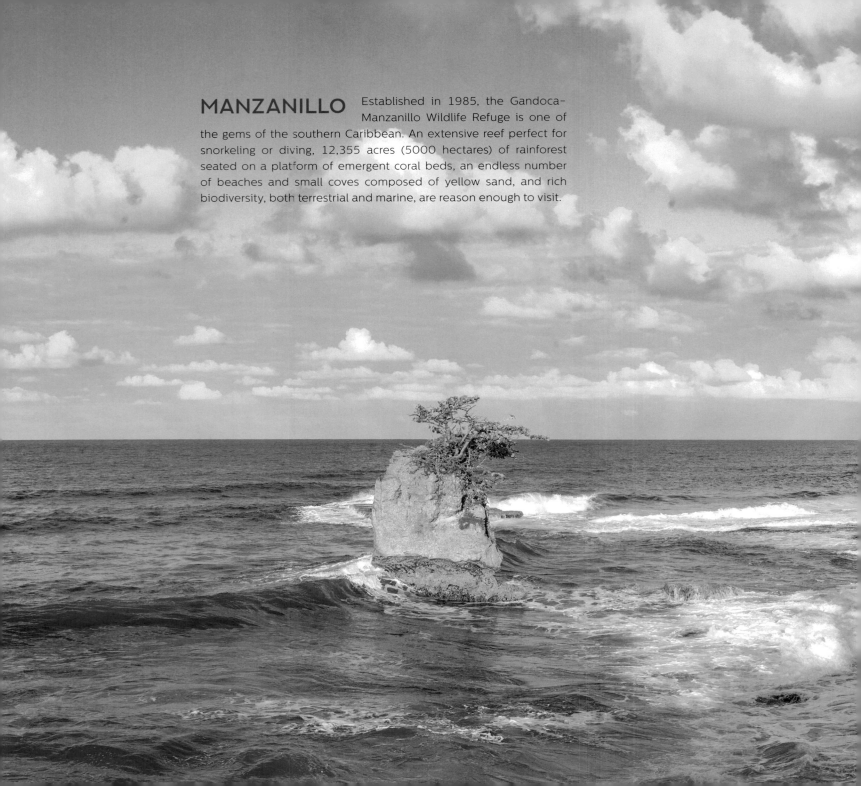

MANZANILLO

Established in 1985, the Gandoca–Manzanillo Wildlife Refuge is one of the gems of the southern Caribbean. An extensive reef perfect for snorkeling or diving, 12,355 acres (5000 hectares) of rainforest seated on a platform of emergent coral beds, an endless number of beaches and small coves composed of yellow sand, and rich biodiversity, both terrestrial and marine, are reason enough to visit.

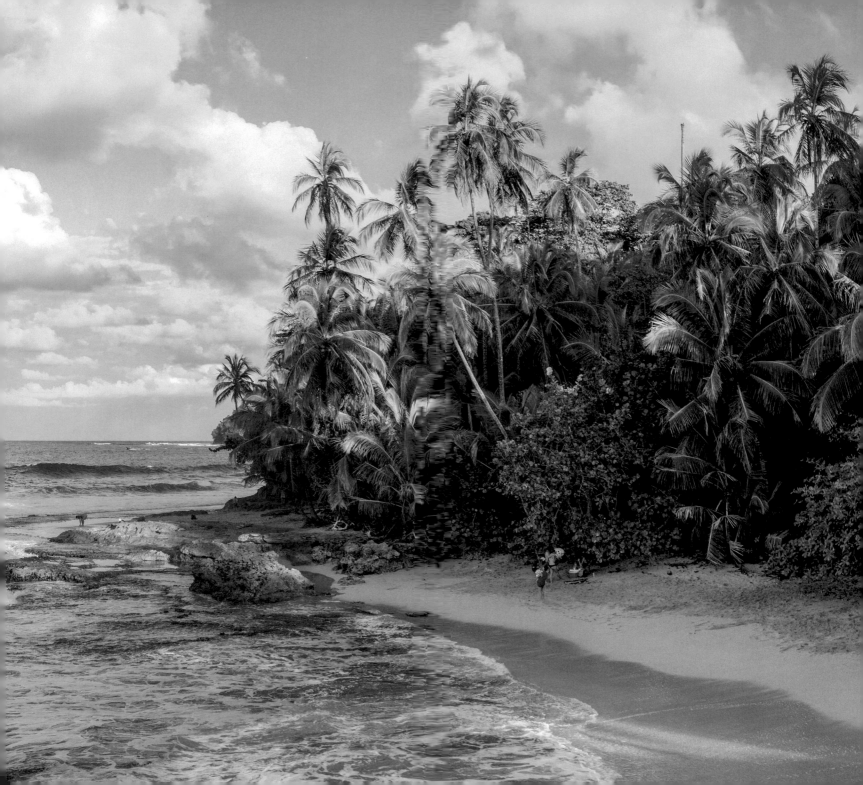

THE ARA PROJECT

In the 1970s, macaw populations in the country declined precipitously due to deforestation and capture for the pet trade. Sometime in the 1980s, it was noted that they had disappeared entirely from the southern Caribbean. But in the past twenty years, several organizations, among them the Ara Project in Manzanillo, have dedicated themselves to breeding macaws in captivity and reintroducing them into their natural habitat. While some biologists have questioned whether birds bred in captivity can succeed in the wild, the fact remains that scarlet macaws are once again a common feature of the southern Caribbean.

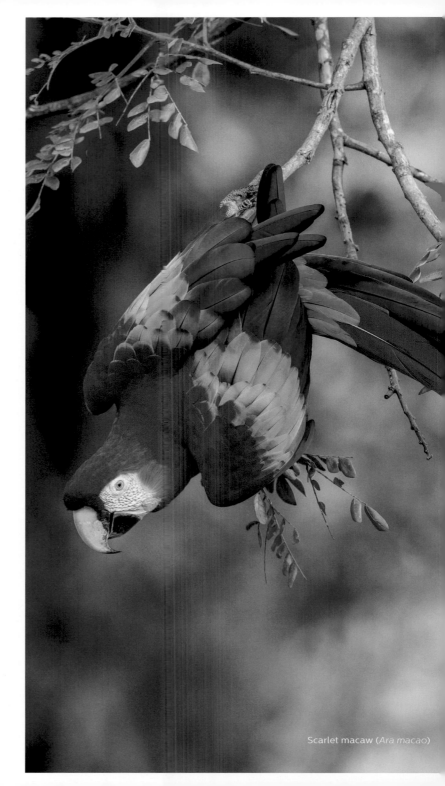

Scarlet macaw (*Ara macao*)

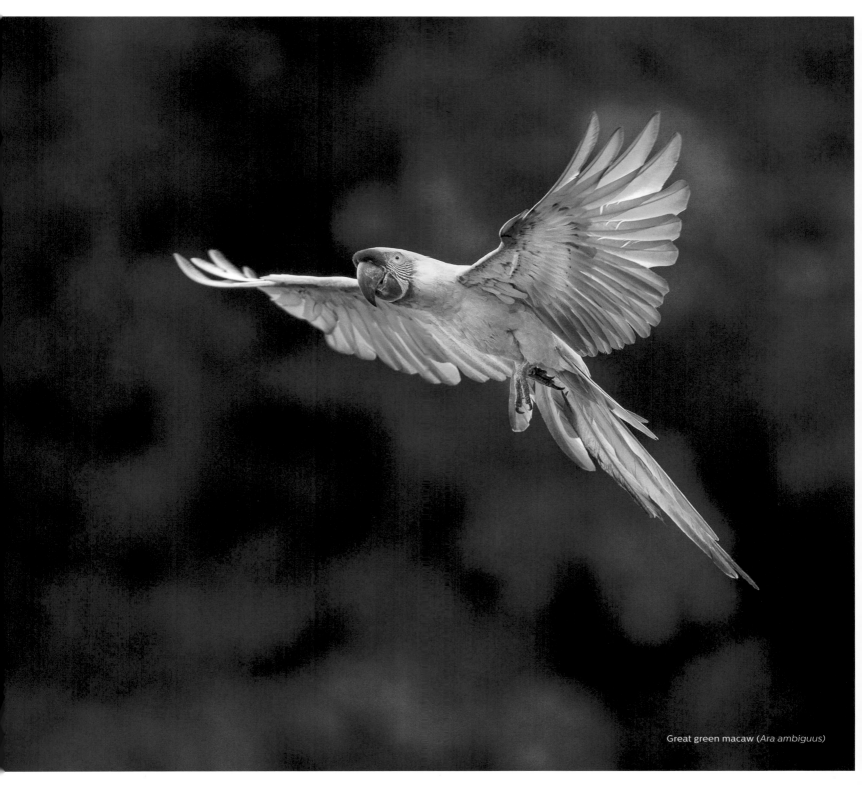

Great green macaw (*Ara ambiguus*)

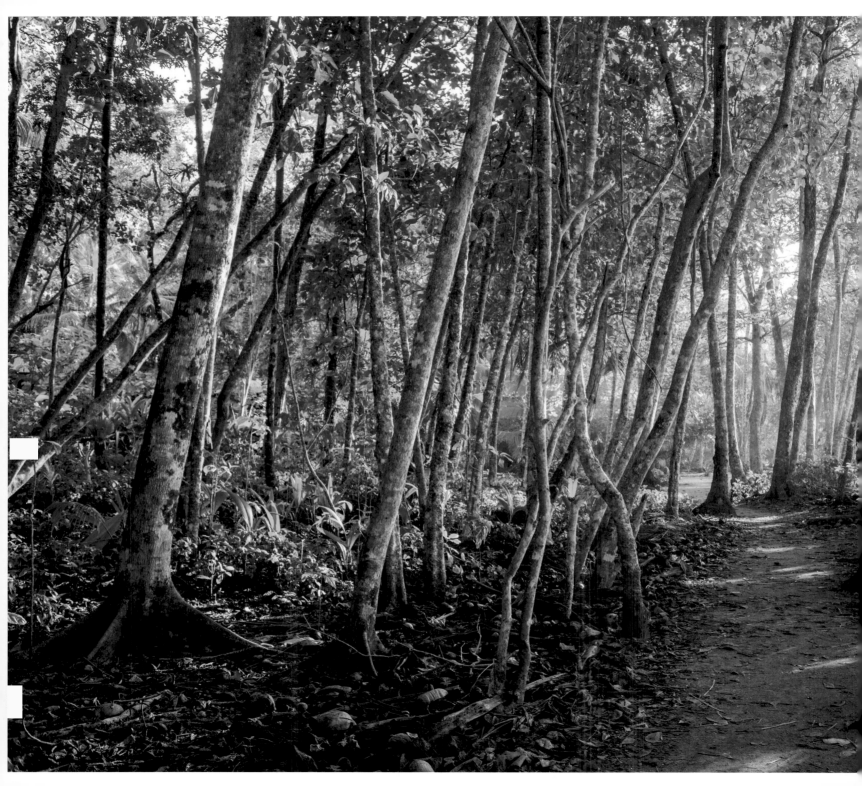

A path that traverses the 3.7 miles (6 km) from Manzanillo to Punta Mona leads the hiker past small inlets with calm tropical waters and through virgin forest filled with wildlife. Continuing south from Punta Mona, a 3-mile (5-km) walk brings you to the golden sands of Gandoca, a small town that lies very close to the border with Panama. It has the most important mangroves in the southern Caribbean and its lagoon is home to otters, manatees, and dolphins.

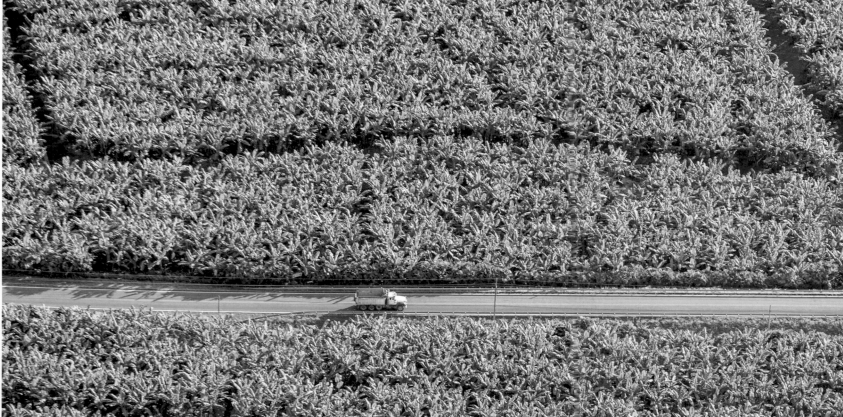

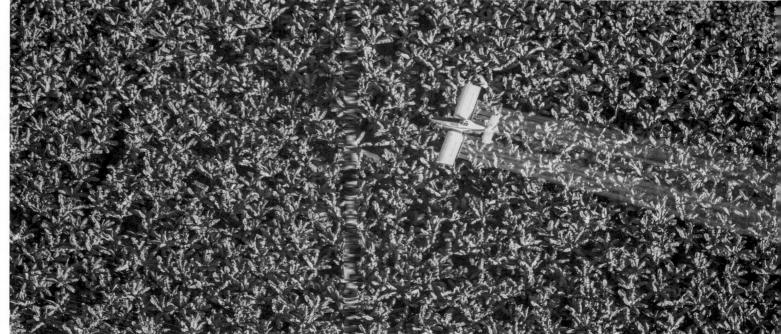

Although banana has long ceased to be Costa Rica's main export product, the 160 square miles (420 km²) devoted to its production lie almost entirely within the province of Limón and cover 10% of its territory. The main problem associated with its cultivation, still today, is the intensive use of toxic pesticides.

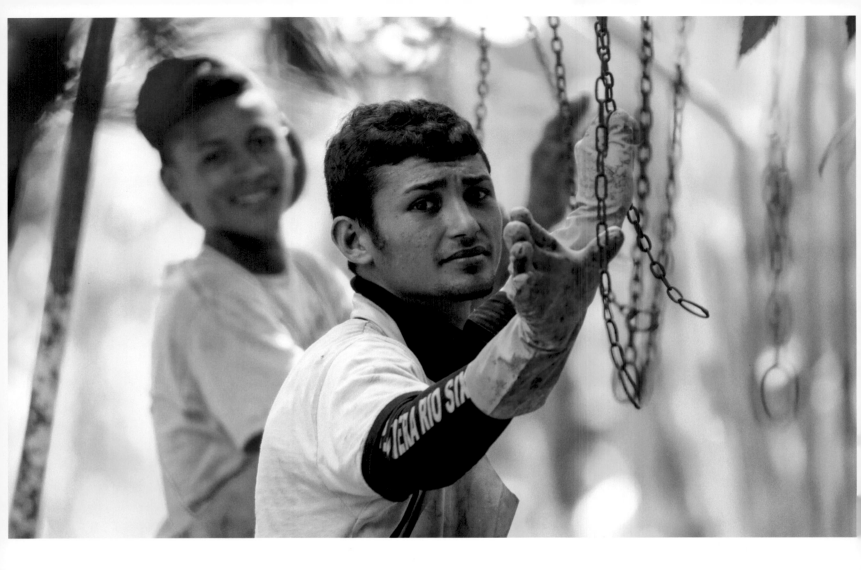

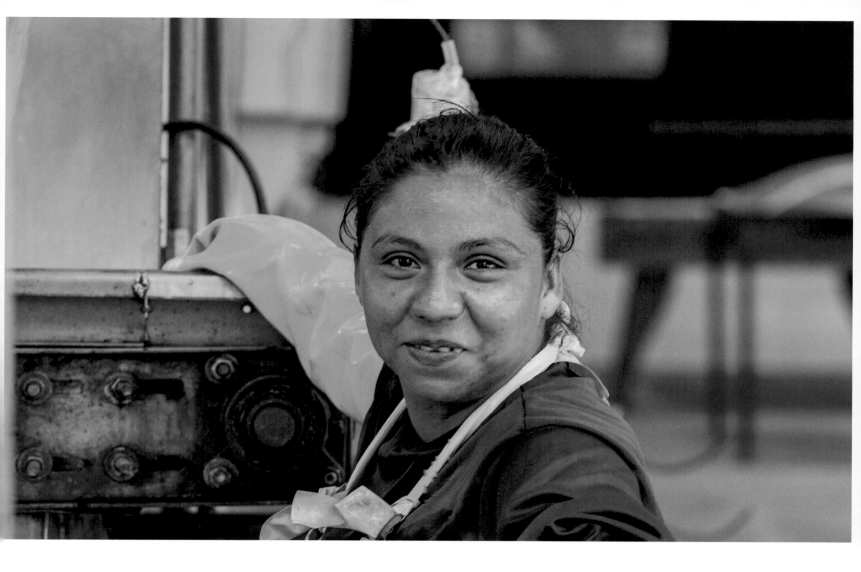

A happy exception in banana cultivation is Platanera Rio Sixaola, which, since 1989, has been producing sustainable bananas certified by the most important global rating agencies. It has reached carbon neutrality, recycles 100% of the water it uses, and its commitment to humane working conditions is reflected in the faces of its workers.

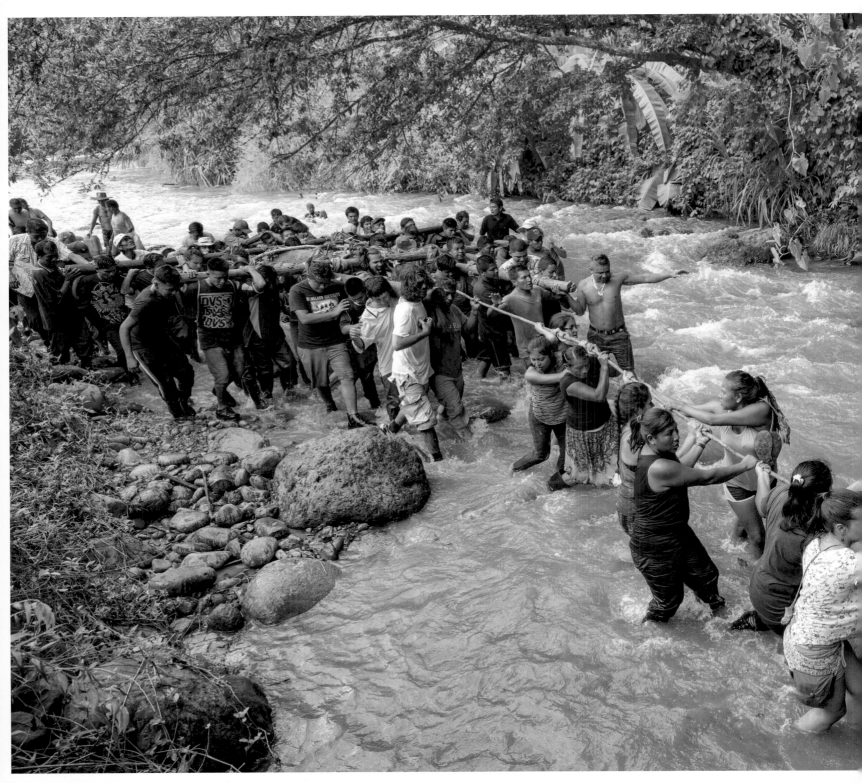

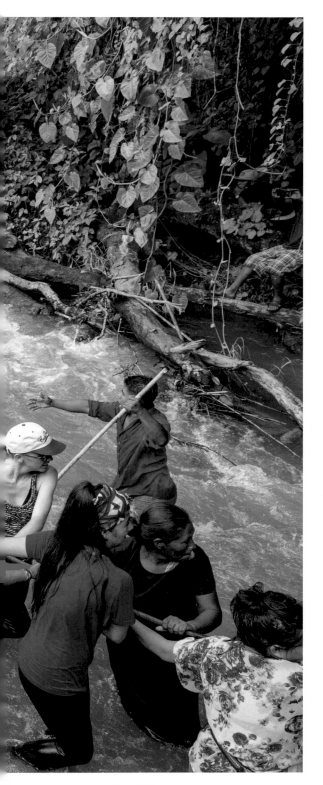

THE ROCK
BRIGADE

Every year, toward the end of September, the indigenous Erbri community carries out the traditional *jala de piedra*, in which they transport a giant boulder from within the forest interior to make it available to the community for grinding corn and cocoa. This ceremony is a way of affirming their commitment to communal work, a central element of their culture.

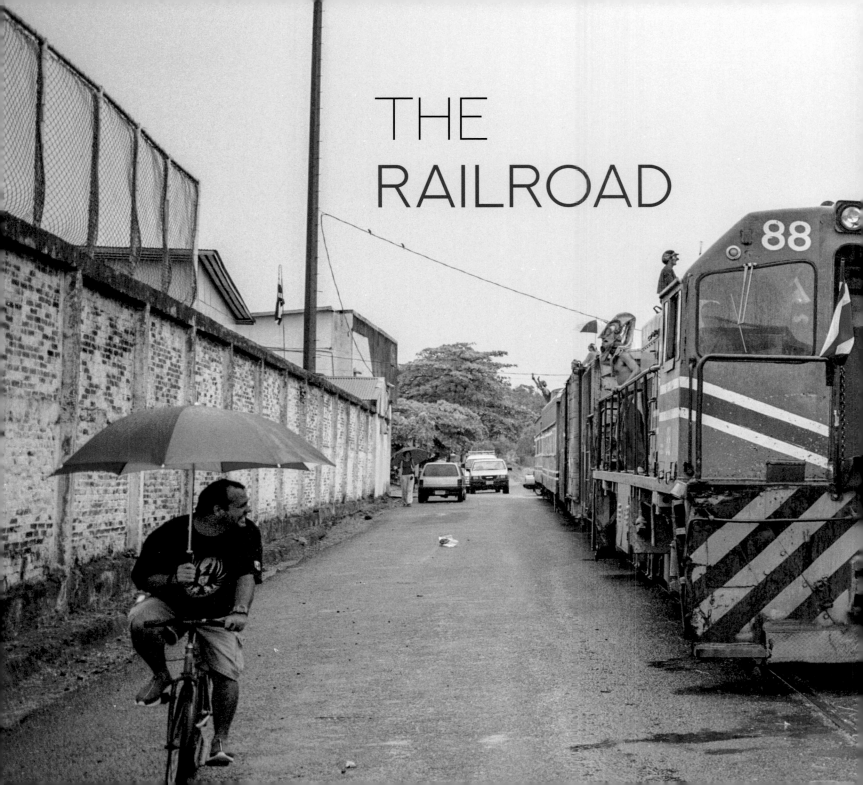

THE
RAILROAD

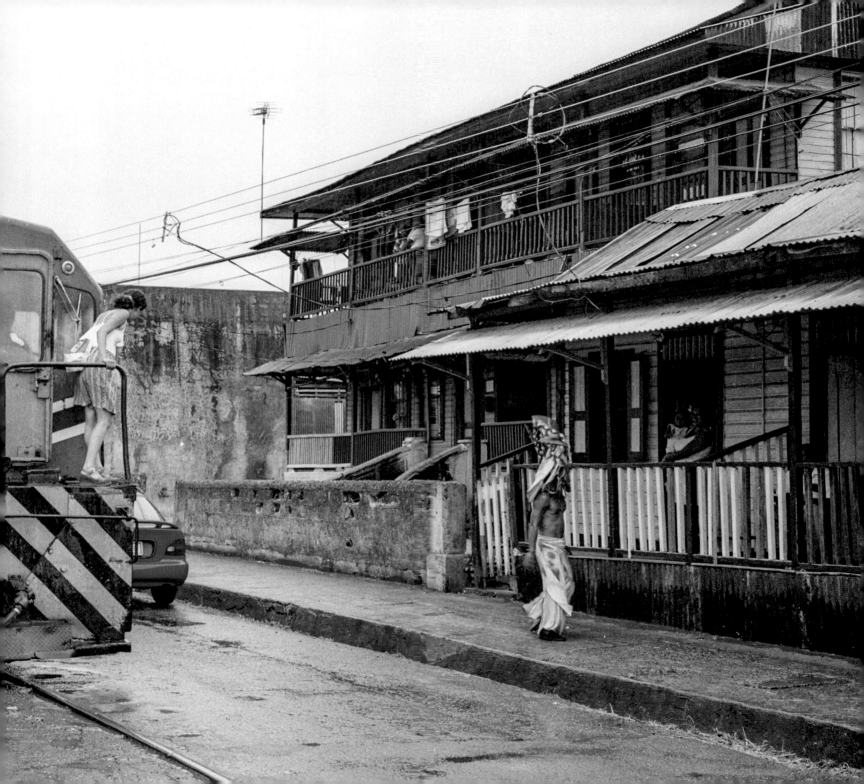

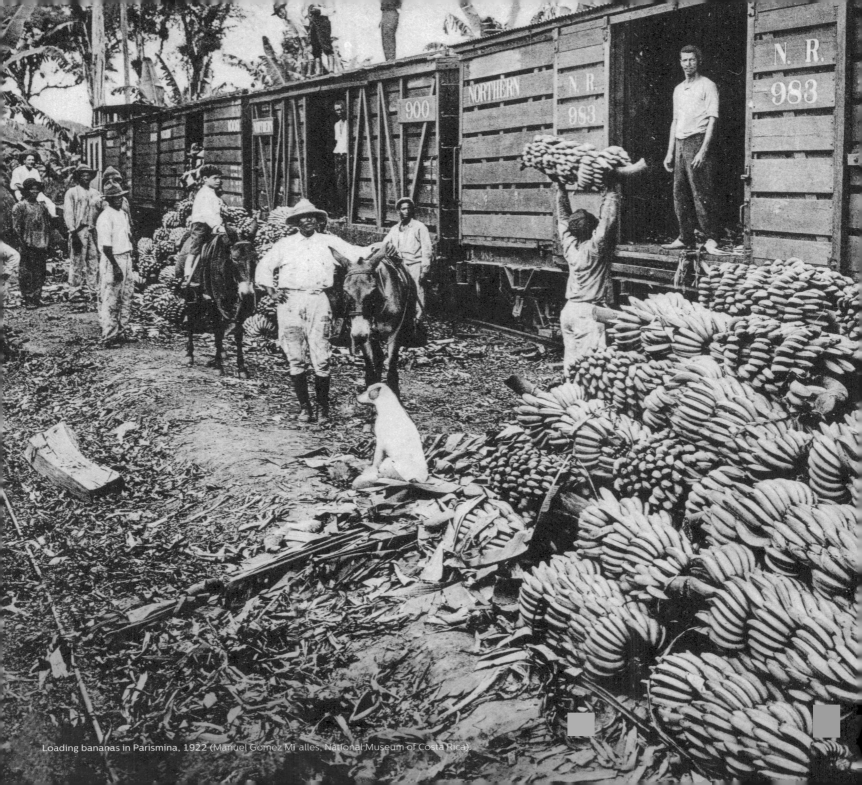

Loading bananas in Parismina, 1922 (Manuel Gómez Miralles, National Museum of Costa Rica).

Despite its name, the history of the city of Limón was shaped not by the lemon tree but by a plant from southeast China carried to America by Catholic missionaries: the banana. That fruit has laid waste to jungles, built railroads, mobilized marine merchant fleets, overthrown governments, ruined great businessmen, raised cities and ports, and marked the destiny of thousands of people of diverse origins.

It is remarkable that the banana, so susceptible to bruising and so quick to rot, has been able to transform so much since the 1870s, turning the Costa Rican Caribbean into a complex and colorful mosaic of international influences. Limón smells of rondon, pizza, pita, cinnamon, honey, lemon, and soy sauce. For decades the city has embraced Chinese, Africans, mulattos, Lebanese, and Italians and other Europeans.

Today, the multitude of people who live in the region is so diverse it is hard to picture it as it once was, an alien unpopulated place. For years, the port of Limón was just the pipe dream of a few politicians. It was "...a poor village of thatch huts inhabited by Afro-Caribbean and mulatto fishermen who didn't know a thing about the country in which they lived," according to official documents of the time.

The region remained largely unchanged until Tomás Guardia, a former general who was anointed president of the country, promoted "the great redemptive work" that would move the province toward the "modern era." He was talking about the railroad. To accomplish this, Henry Meiggs was hired, a famous North American contractor who had laid more than a thousand miles of rails in Chile and Peru, where he succeeded

in spite of the snowy peaks, impenetrable mountains, and the deep chasms and ravines of the Andes mountains.

The railroad was supposedly built to carry coffee to England. With a silver shovel and the conviction that a country without a railroad was doomed to failure, work began in 1871. The railroad would turn the forgotten town of Limón, of which no one had spoken since Columbus's brief visit, into a port that would give work and meaning to the 148,000 inhabitants of Costa Rica.

As work proceeded on laying tracks—and as disasters accumulated—the contract to build the railroad was passed from hand to hand. Henry Meiggs passed it on to his nephew Henry Keith, whose death from yellow fever in 1875 stalled the project near the Pacuare River, at mile 35—about a third of the way to completion.

In exchange for finishing the railroad, the Costa Rican government signed a new contract with the deceased Keith's nephew, Minor Keith, which granted "800,000 acres of unexploited national territory [an area larger than the state of Rhode Island, or about 2% of Costa Rica's territory], including all the natural resources it might contain.' The concession also included all the territory on either side of the train tracks, as well as lands suited for the building of docks, warehouses, and a train station in Limón. Keith received tax-exempt status for 20 years and the concession to run the railroad for 99 years. This deal laid the groundwork for his empire and would link the railroad and the banana industry for years to come.

Keith began exporting the fruit in 1874, with 250 bunches. He was exporting 11 million bunches per year by 1913, at which point United Fruit—founded by him in 1899—had more than 70,000 workers on its payroll. The speed of the railroad played a fundamental role in the export of bananas. Because of the lack of refrigeration, the fruit needed to reach ports of destiny and be sold before it became ripe, a maximum of 20 days.

Bananas and the railroad are largely responsible for Costa Rica's ethnic diversity. Not since the first Spanish settlers had so many foreigners come to Costa Rica. In the late 19th century, people began to arrive from around the world: Chinese workers recruited in San Francisco and Macau, Hindi workers or "coolies," Irish and Scotsmen brought

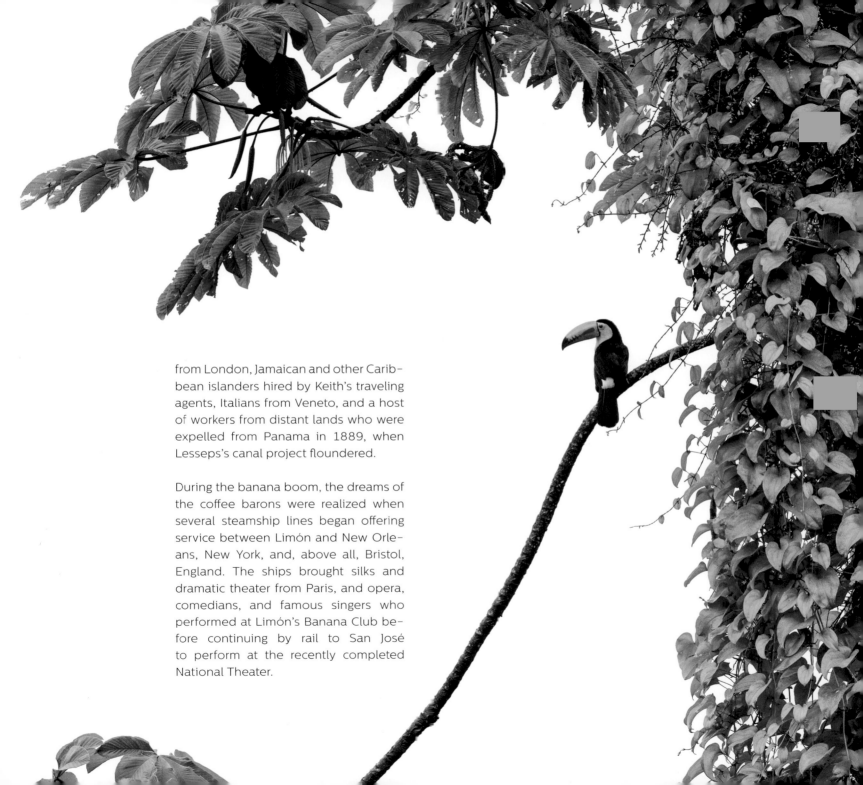

from London, Jamaican and other Caribbean islanders hired by Keith's traveling agents, Italians from Veneto, and a host of workers from distant lands who were expelled from Panama in 1889, when Lesseps's canal project floundered.

During the banana boom, the dreams of the coffee barons were realized when several steamship lines began offering service between Limón and New Orleans, New York, and, above all, Bristol, England. The ships brought silks and dramatic theater from Paris, and opera, comedians, and famous singers who performed at Limón's Banana Club before continuing by rail to San José to perform at the recently completed National Theater.

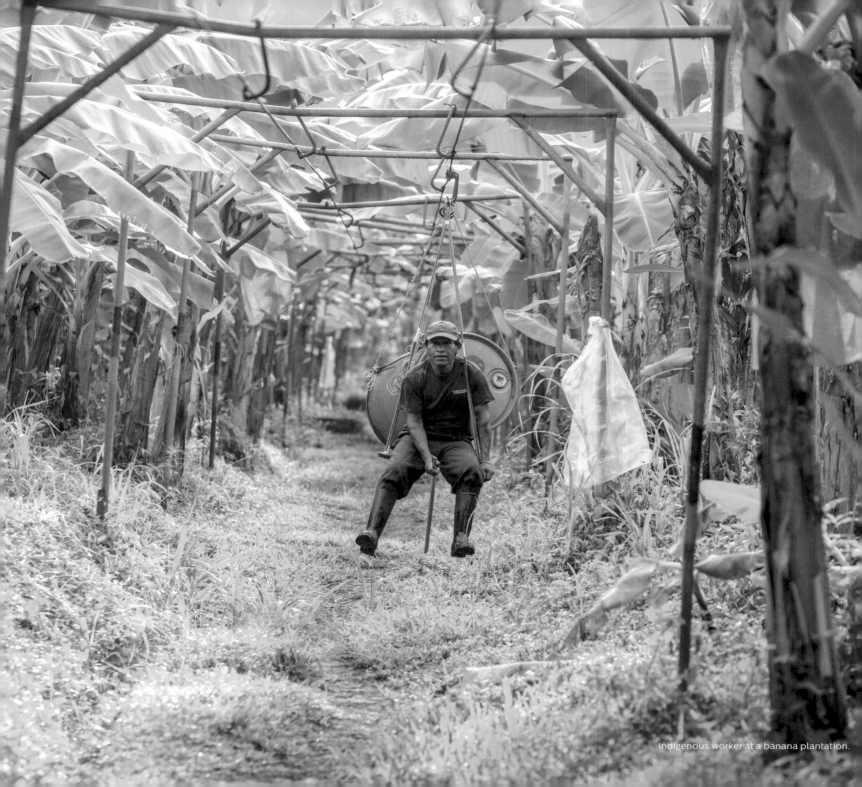

Indigenous worker at a banana plantation.

The bilingual papers published in Limón during the 1920s describe it as the place where scientific and technological advances first made their appearance on Costa Rican soil. The banana aristocrats and the governing classes would travel to Limón to watch the passing of the great fleets of the U.S. Navy en route to the Panama Canal, and to admire the hydroplanes that carried out maneuvers in the bay.

Limón was primarily English-speaking, and language has always in part separated it from the rest of Costa Rica. In the years that the banana industry was operating in Limón, the local population and the migrant Afro-Caribbean community had little contact with the Costa Rican government—95 miles (152 km) to the west. The communication that did occur was usually mediated by the North Americans who ran the economy, banana production, transportation, and the docks.

United Fruit pulled out of the Costa Rican Caribbean lowlands in the 1930s and 40s, taking with it bridges, railways, and company housing, all of which were dismantled and saved for use in their new plantations in the southern Pacific region of Costa Rica, which would serve markets on the west coast of the United States. In a period of ten years, Limón went from being the opulent base of operations to an abandoned, forgotten province. A few vestiges of United Fruit remain, including discontinuous sections of railway, a concrete tunnel on the way to Suretka that can be reached via the road to Sixaola, and a few isolated settlements.

The ecological inheritance of United Fruit is thousands of acres of abandoned lands with jungles that have been completely obliterated. At that time, the virgin forest fell into the category of "uncultivated lands" or "wastelands," standing in the way of development.

No one thought of defending the land and the wildlife. And the thousands of cubic feet of felled timber went unused because the lack of transportation made it commercially unviable. The practice of clearing jungle persisted into the 1970s, when banana production expanded toward the Rio Frío area and several primary forests were devastated.

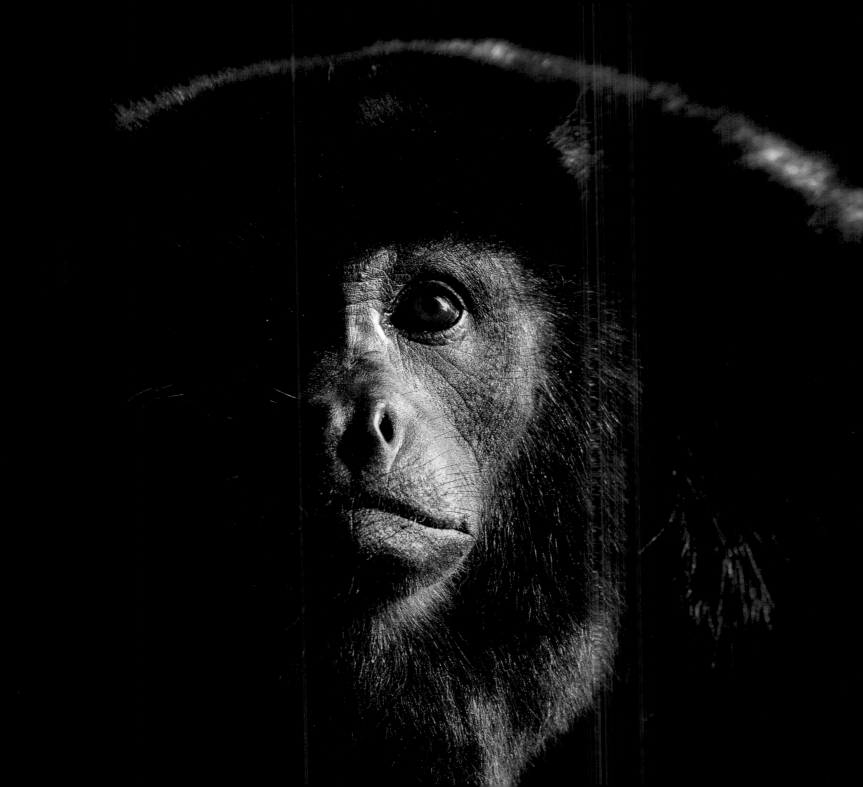

"Nobody thought about the damage," confessed Stanley Black, a former manager of Standard Fruit Company. "At the time, the government and everybody congratulated us for clearing so much forest. They didn't see it as deforestation but as progress."

Today, the jungle that once "stood in the way" of the treasure hunters and obstructed the great engineering projects and the forward momentum of economic development has acquired an incalculable value. Along the old railroad line, on the slopes that climb the Talamanca Mountains, in lands whose steep slopes were never suited for agriculture, the last vestiges of lowland rainforests survive, including La Selva, Tirimbina, Barbilla National Park, and other rainforest "islands." Now, the trails that crisscross the virgin forests generate more wealth than the railroad and the banana, pineapple, and coffee plantations put together. "Progress" today speaks a different language; it speaks the call of the howler monkeys and the songs of birds.

Howler monkey (*Alouatta palliata*)

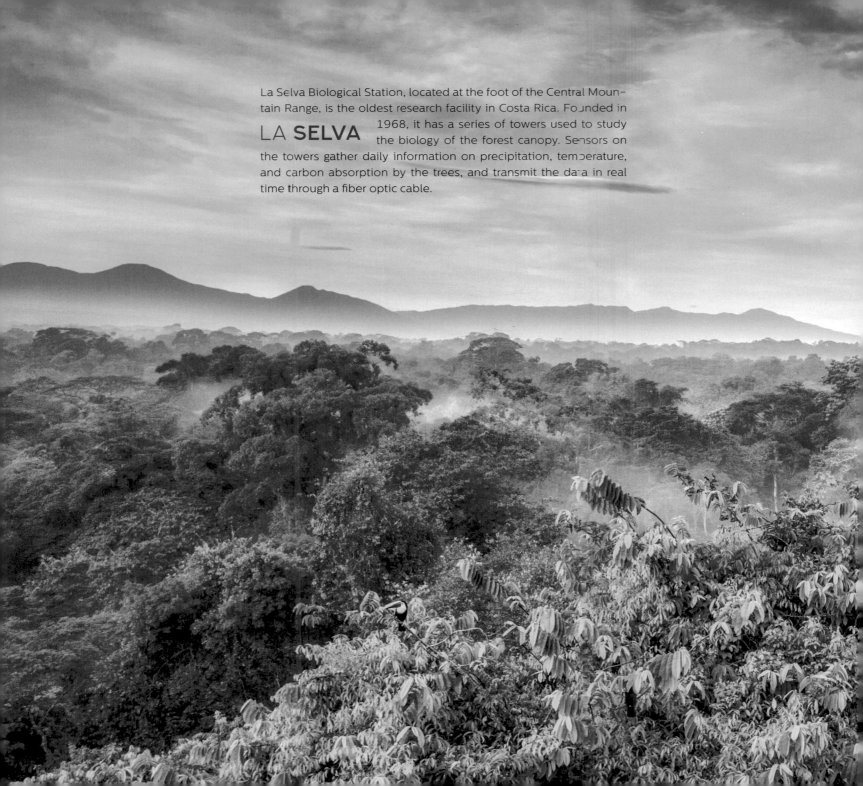

La Selva Biological Station, located at the foot of the Central Mountain Range, is the oldest research facility in Costa Rica. Founded in

LA **SELVA**

1968, it has a series of towers used to study the biology of the forest canopy. Sensors on the towers gather daily information on precipitation, temperature, and carbon absorption by the trees, and transmit the data in real time through a fiber optic cable.

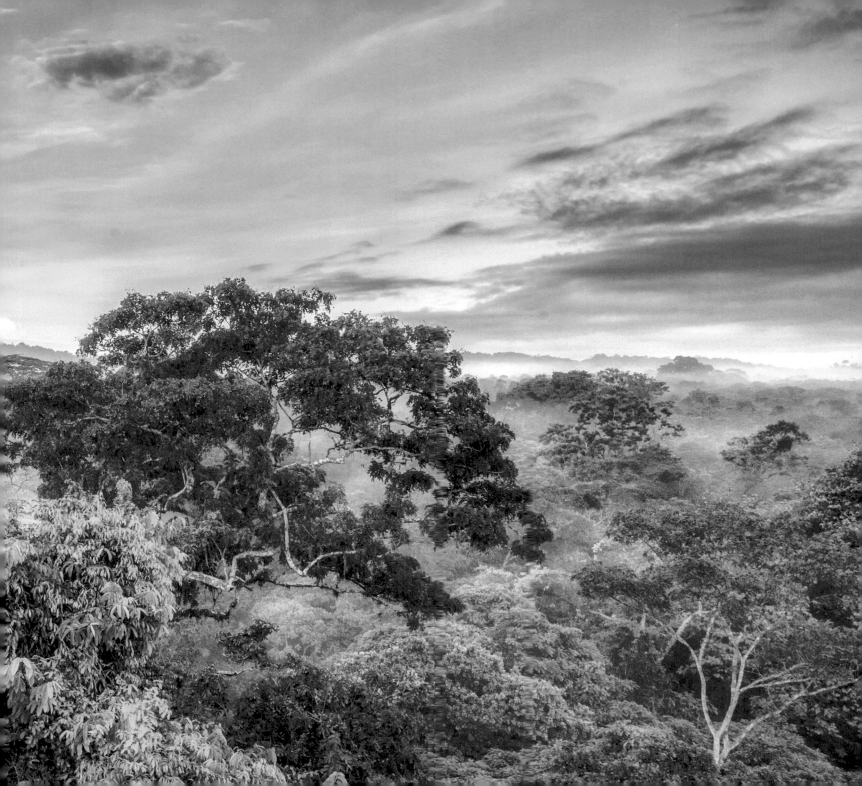

THE STAR OF THE FOREST

La Selva Biological Station is located within humid tropical and premontane forest. Primary forest covers about 73% of the total area of the station. There is also a much visited wetland area, which is home to the red-eyed leaf frog (*Agalychnis callidryas*), the most photographed animal in the country. The area hosts several other research stations. Of those open to the public, the best known is probably Tirimbina.

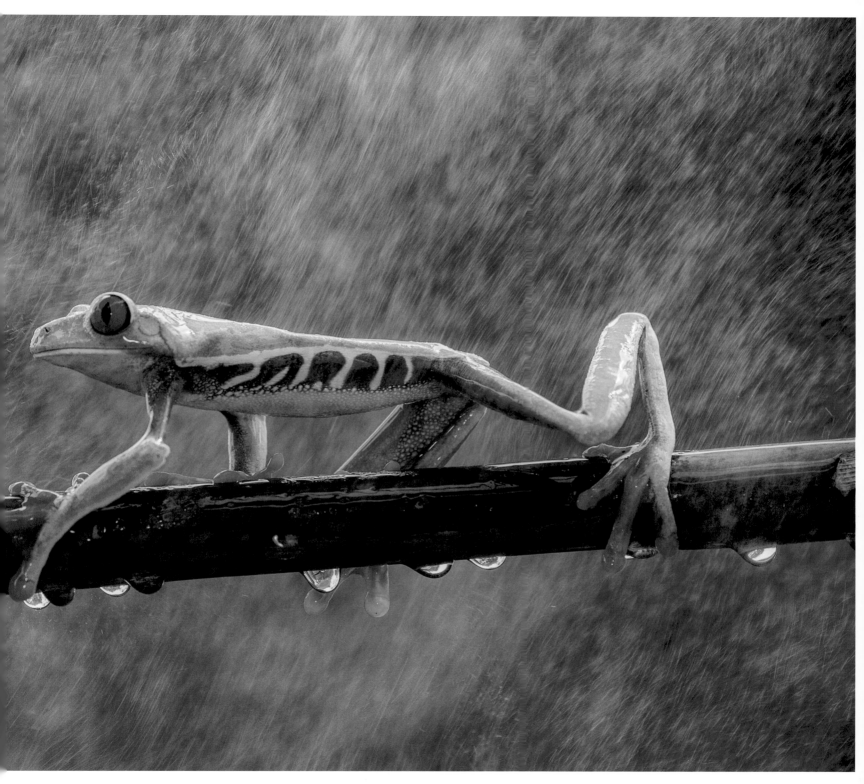

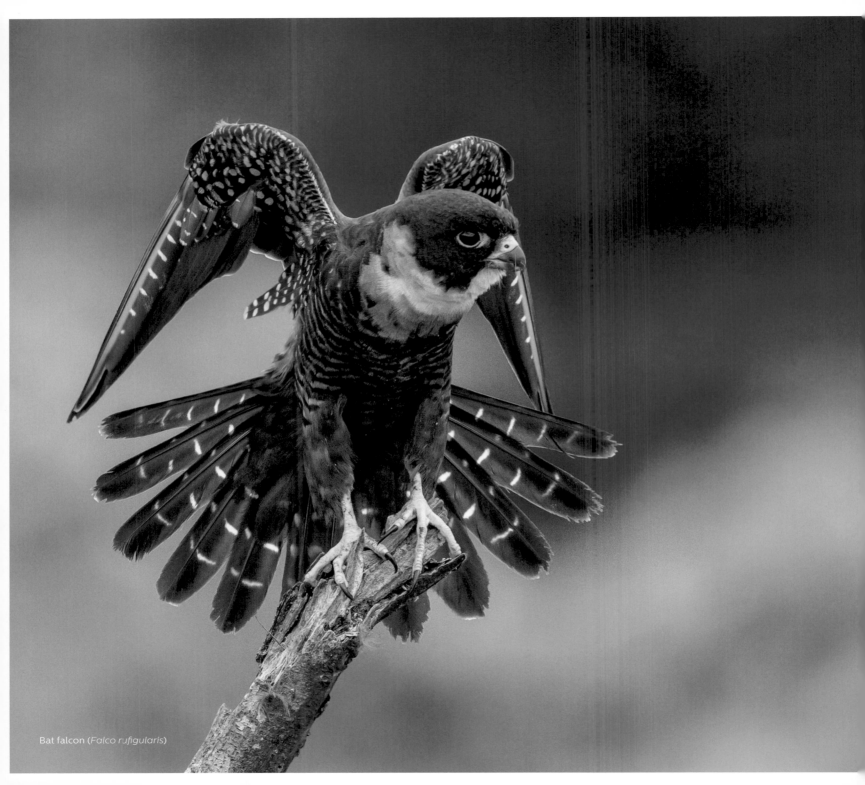

Bat falcon (*Falco rufigularis*)

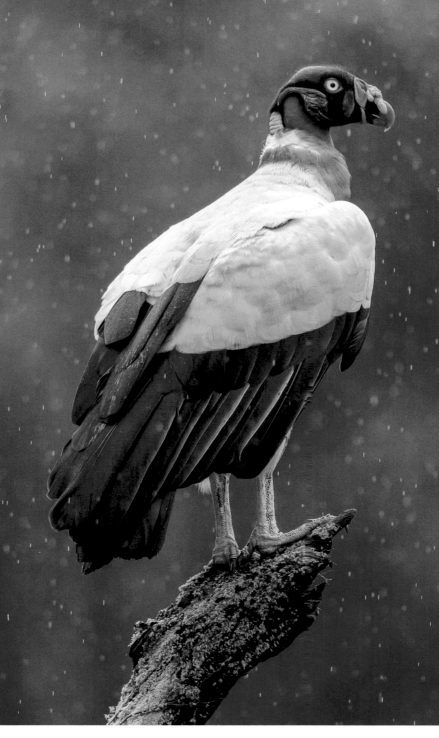

King vulture (*Sarcoramphus papa*)

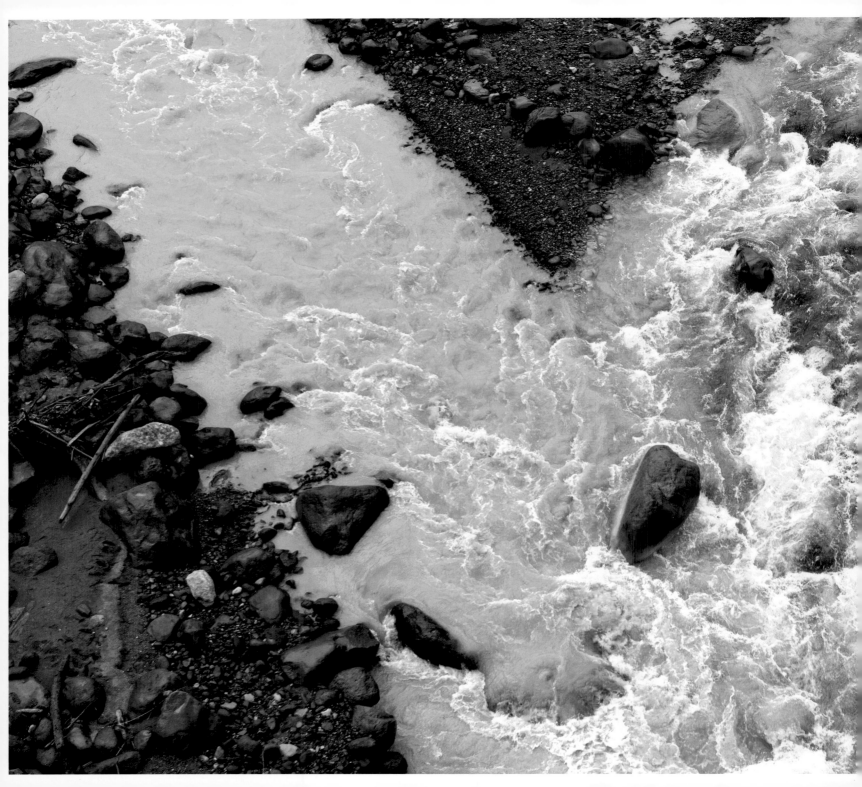

COLORFUL RIVERS

The meeting of these two rivers, Rio Sucio and Rio La Hondura, has been immortalized in several documentaries and in the Ridley Scott film *1492*. Contrary to what many people think, the color of the Rio Sucio (Dirty River) is not created by dissolved mud. Some 40% of the bacteria that live in these waters belongs to the genus *Gallionella*, which oxidizes the pyrites carried in the river, producing an iron compound of an intense yellowish color.

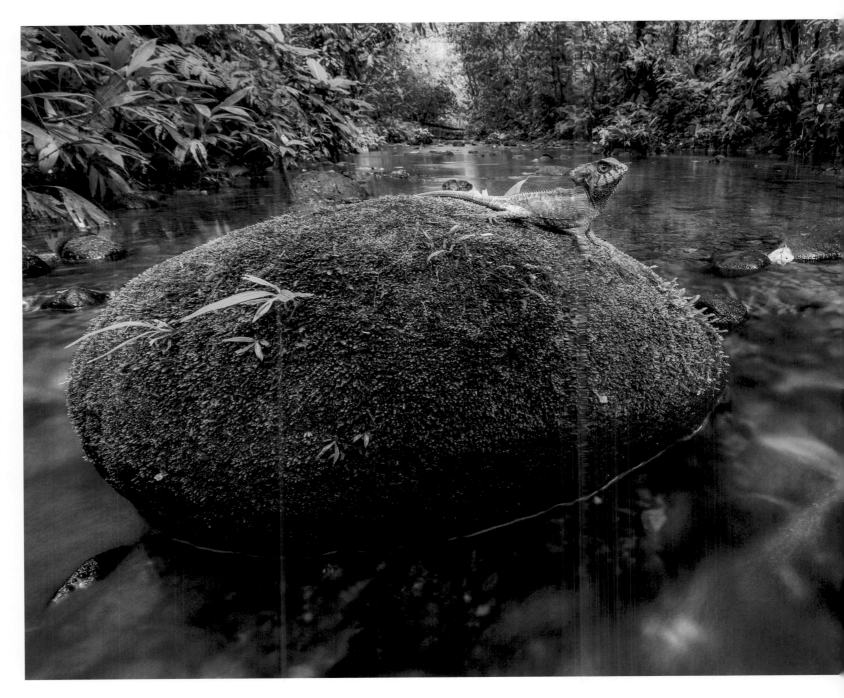

Reptiles and birds are always attentive to the attention of photographers. Their gaze never wavers and they are ever vigilant.

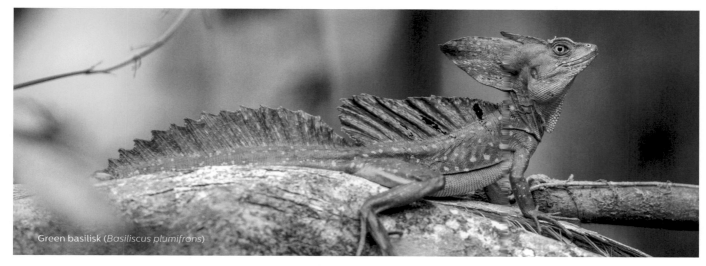
Green basilisk (*Basiliscus plumifrons*)

Helmeted iguana (*Corytophanes cristatus*)

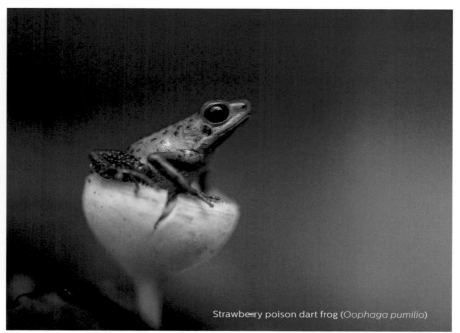
Strawberry poison dart frog (*Oophaga pumilio*)

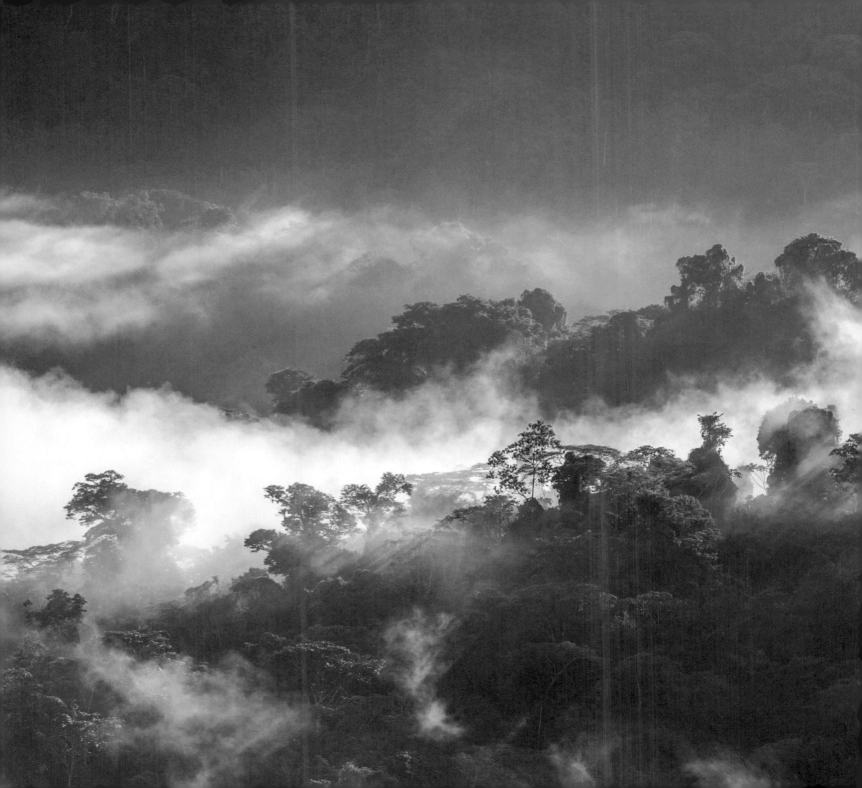

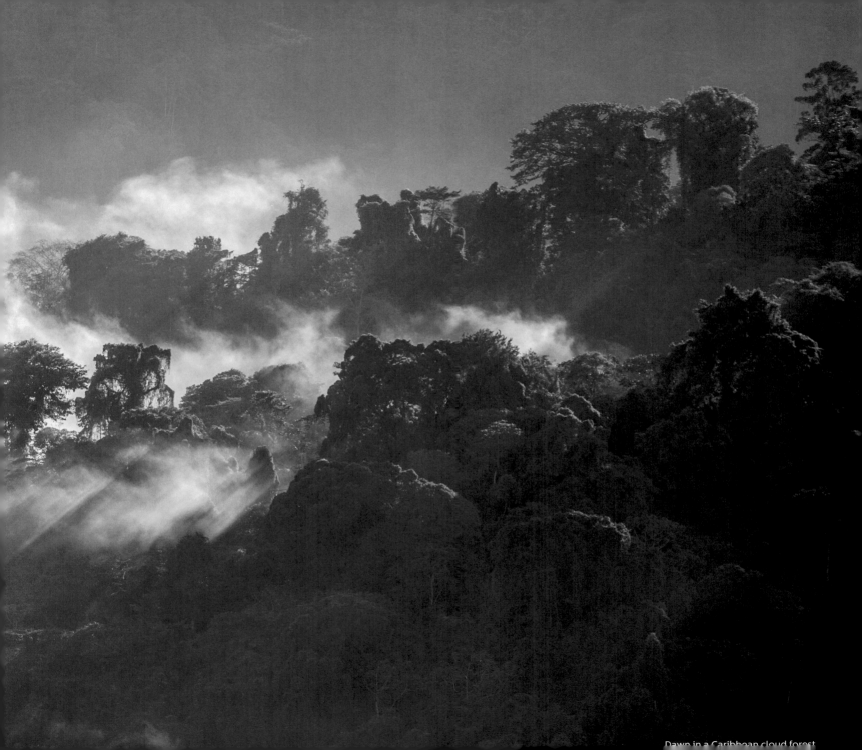

Dawn in a Caribbean cloud forest

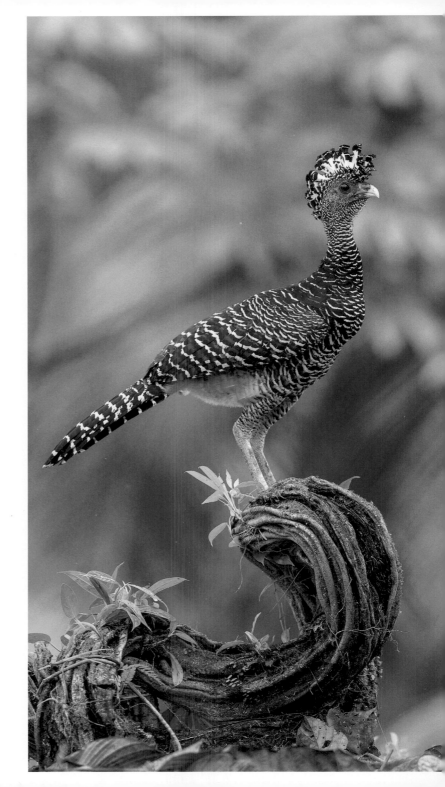

OF HUMMINGBIRDS AND
CURASSOWS

Females of the great curassow (*Crax rubra*) are polymorphic, which is to say they come in different colors, or morphs. The barred appearance of this morph makes it the most striking of the three.

Male long-tailed hermit hummingbirds (*Phaetornis longirostris*) form singing assemblies for the purpose of courting females; as many as 25 males come together at one time, usually next to a stream. Their rapid metabolism, like that of other hummingbirds, requires them to supplement their diet with proteins, as the sugar they glean from flowers is burned up very quickly.

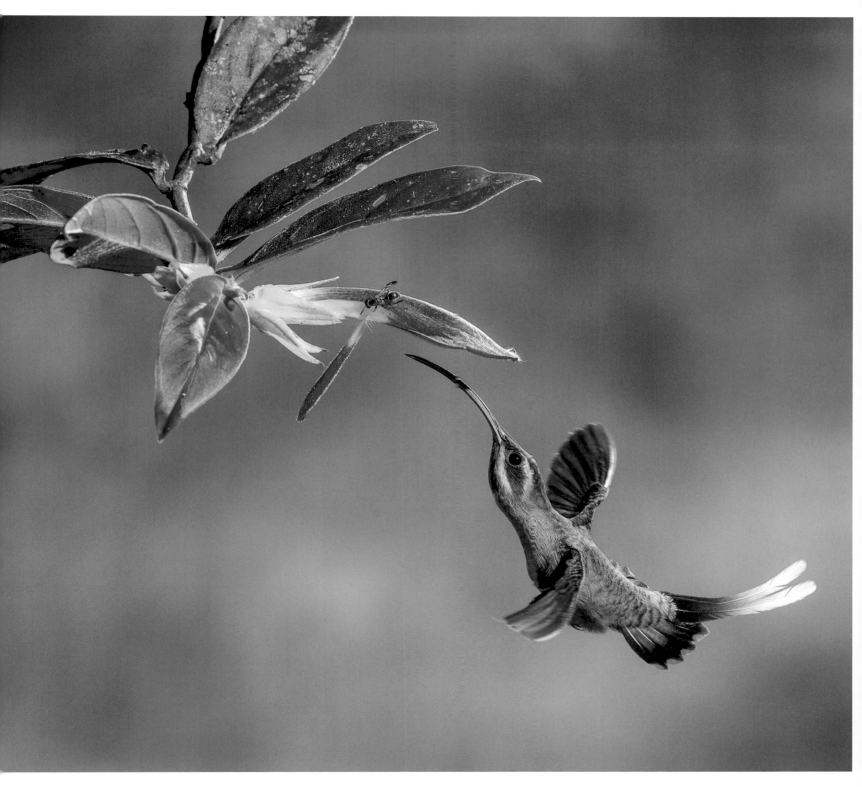

MODERN
KNIGHTS

The ribbon races have their origin in the ring game of ancient medieval tournaments and were introduced in America during colonial times. They were once the most important feature of community celebrations, and in the 19th century they were the principal means of collecting funds for community and religious purposes. Today, for the most part, they have been all but forgotten, although in Guácimo de Limón and in some towns in Guanacaste the races are still held.

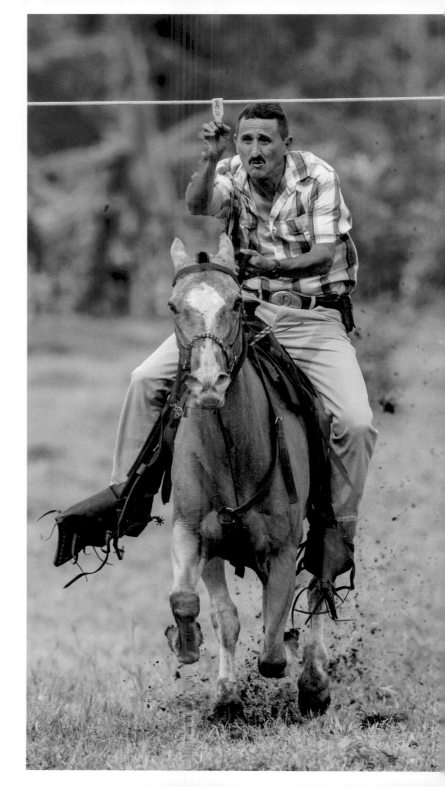

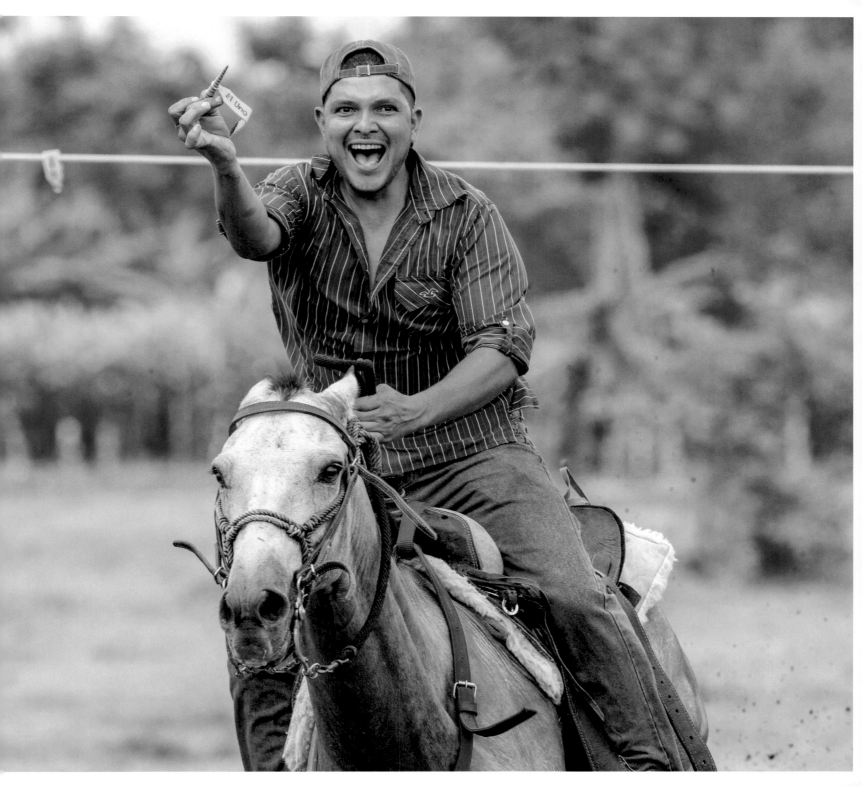

Pineapple farm, Siguirres

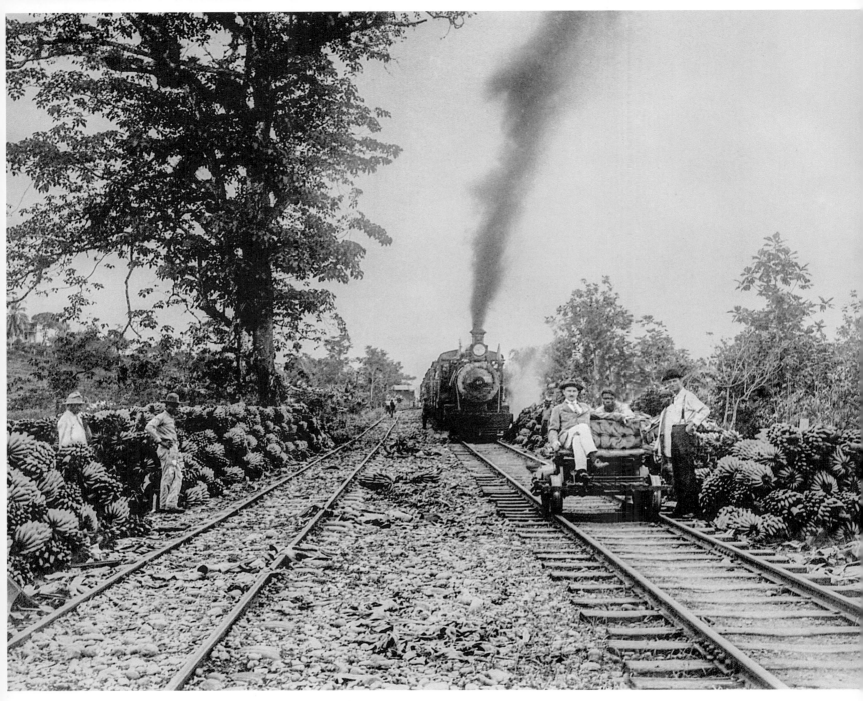

The alliance between the banana barons and the railroad was immortalized in this photo, taken in the 1920s (photographer unknown).

INDEX

CREDITS

PHOTOGRAPHERS

Unless indicated below, all photographs
are by Luciano Capelli.
Gregory Basco: pp. 18, 19, 21 (top), 28, 32, 38, 61,
64, 77, 94, 96, 99, 104, 105 (bottom), 108, 109
Jeffrey Muñoz: pp. 15, 30 (bottom), 76, 100, 101
Adrian Hepworth: pp. 34, 35, 44, 69
Nick Hawkins: pp. 13, 24, 72
Alvaro Cubero: pp. 20, 59, 60
Pepe Manzanilla: pp. 9, 91
Diego Mejías: p. 21 (bottom)
Jorge Chinchilla: p. 26
Jen Guyton: p. 31
Bloque Documental: p. 84

COVER PHOTOS

Luciano Capelli,
Gregory Basco

CONCEPT

Luciano Capelli,
Stephanie Monterrosa,
John Kelley McCuen

LAYOUT DESIGN & PHOTO RETOUCHING

Francilena Carranza

LOGO, MAP & ILLUSTRATIONS

Elizabeth Argüello

ORIGINAL TEXT

Yazmín Ross,
Luciano Capelli

TEXT EDITOR

Camila Schumacher

ENGLISH ADAPTATION

Carlos de la Rosa,
John Kelley McCuen

TEXT REVIEW

John Kelley McCuen,
Stephanie Monterrosa

PRODUCTION

Luciano Capelli,
John Kelley McCuen

PRODUCTION ASSISTANT

Stephanie Monterrosa

ABOUT THE PUBLISHERS

Cornell University Press fosters a culture of broad and sustained inquiry through the publication of scholarship that is engaged, influential, and of lasting significance. Works published under its imprints reflect a commitment to excellence through rigorous evaluation, skillful editing, thoughtful design, strategic marketing, and global outreach. The Comstock Publishing Associates imprint features a distinguished program in the life sciences (including trade and scholarly books in ornithology, botany, entomology, herpetology, environmental studies, and natural history).

Ojalá publishes illustrated books about the biodiversity and cultural identity of Costa Rica. With every title, we strive to intertwine images and text to transport readers on a voyage through this extraordinary country.

Zona Tropical Press publishes nature field guides and photography books about Costa Rica and other tropical countries. It also produces a range of other products about the natural world, including posters, books for kids, and souvenirs.

COSTA RICA REGIONAL GUIDES

GUANACASTE

MARIA MONTERO AND LUCIANO CAPELLI

MONTEVERDE & ARENAL

MARIA MONTERO AND LUCIANO CAPELLI

CARIBBEAN COAST

YAZMIN ROSS AND LUCIANO CAPELLI

CENTRAL VALLEY

AVAILABLE IN 2020

MANUEL ANTONIO

AVAILABLE IN 2020

OSA & CORCOVADO

AVAILABLE IN 2020

Principal font: Centrale Sans